NUNEATON PUBS

All the best

PETER LEE

April 2016

AMBERLEY

First published 2016

Amberley Publishing
The Hill, Stroud
Gloucestershire, GL5 4EP

www.amberley-books.com

Copyright © Peter Lee, 2016
Maps contain Ornance Survey data.
Crown Copyright and database right, 2016

The right of Peter Lee to be identified as
the Author of this work has been asserted in
accordance with the Copyrights, Designs and
Patents Act 1988.

ISBN: 978 1 4456 5011 1 (print)
ISBN: 9781 4456 5012 8 (ebook)

British Library Cataloguing in Publication Data.
A catalogue record for this book is available from
the British Library.

Typesetting by Amberley Publishing.
Printed in the UK.

Contents

Map* 5

Introduction 7

Central Nuneaton 15

Attleborough 69

Stockingford 86

Bibliography 96

Acknowledgements 96

*Map numbers refer to numbered pubs throughout.

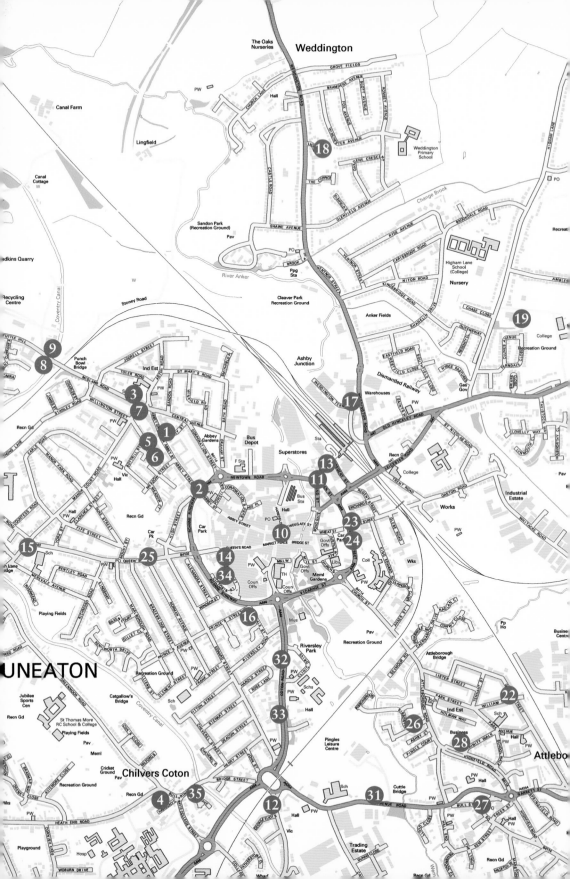

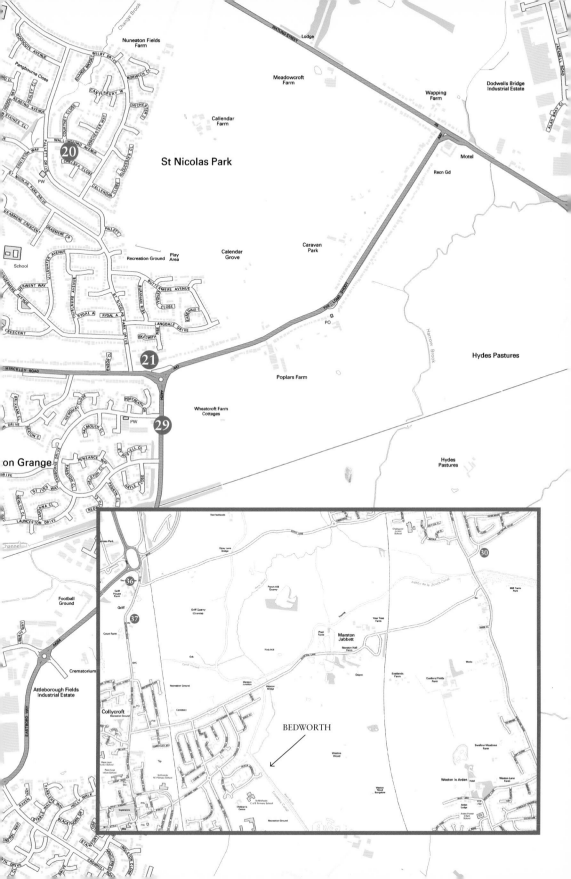

Introduction

There is no private house in which people can enjoy themselves so well as at a capital tavern. You are sure you are welcome, and the more good things you call for, the welcomer you are. There is nothing which has yet been contrived by man by which so much happiness is produced as by a good tavern or inn.

Dr Samuel Johnson, *Boswell's Life* (1776)

Pubs were an important part of our social history because they were, and still are to some extent, the working man's front parlour. This is particularly true of the days when people lived in cramped and squalid conditions, in tiny houses shared with quarrelsome wives and lots of noisy children. In the pub, or beerhouse, our ancestors could meet with their friends with an endless supply of liquid refreshment to dull their senses and blot out the misery of their daily life.

A whole chapter of people's lives were acted out in the bar. Pubs were, and still are, a resort of comfort in times of relaxation, distress, and marital infidelity. Back then they became political headquarters and were the home of sporting clubs, friendly societies and entertainments such as darts and dominoes (all taken seriously in the convivial surroundings of the bar). Dampening the stresses and strains of your working day and putting the world to rights over a warm pint, you could indulge in lotteries, betting, and gaming pursuits; maybe even imbibe the local paper (if you could read) and find the warmth, friendlier and cleaner facilities that sometimes one would not have expected at home. Nevertheless pubgoers, like actors on a stage, once their part at the bar was played out, the soap opera of their lives was forgotten. The public house lived on with a new clientele, new decor, and different (or indifferent) beer. The pub is an essential and integral part of the history of our town, Nuneaton, and the British Isles in general.

Public houses also played a key part in the commercial life of the area. The inns and hotels provided bed, board and dinner for visitors and commercial travellers. They fed and watered their horses, and provided a stopping place for stage coaches and cartage operators. Business was contracted in the bar in the days before offices were the everyday part of life. Even today some of the best business deals are carried out over a 'pie and a pint'.

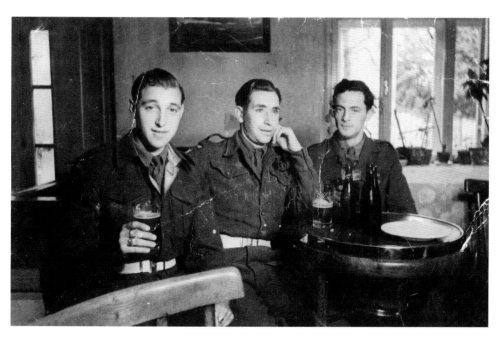

Local soldiers return home on leave for a quiet pint in a Nuneaton pub.

To differentiate between different types of public houses, here is a brief summary. A pub or a public house was, as its name implies, a house for the public to use to purchase beer and a full range of wines and spirits. Most often it did not provide accommodation, sometimes it did. Inns were what you might term an 'upmarket' pub. Landlords with pretensions called their pub an inn, or even a hotel, quite often without justification. Sometimes they provided accommodation, but sometimes not. You might expect a better level of decorum and more convivial surroundings at an inn, but you could not guarantee it. Beerhouses on the other hand, were able to sell beer only. Taverns, like inns, were upmarket pubs, or possibly pubs that simply called themselves taverns. Proper hotels, of course, provided a full range of accommodation, food and liquid refreshment. Generally the gentry and middle classes used hotels: there was less swearing and more decorum in the bar!

Beerhouses were found throughout the district and informally set up in people's front rooms, where a chance of a bit of additional income could be obtained. In a town of courts and yards like Nuneaton, the owner of the plot of land with his good front house facing the main street, who had filled up his back yard with tenement cottages (known locally as courts and in other areas, yards) could turn his parlour into a beerhouse, thereby scraping a few more coppers out of his poverty-stricken tenants. In October 1830 a new Act of Parliament removed 2s 8d beer duty from a barrel of beer along with the need for a license, as long as beer was all that you sold. New beerhouses sprung up all over Nuneaton, but it seems this sudden boom was short-lived. Many disappeared quickly because the owners either became too fed-up with the bad behaviour of their customers, or they passed away. Many only lasted as long as the proprietor could be

bothered to carry on the business. Although, some of the old beerhouses established back in 1830 have stood the test of time and are still going today as fully-fledged pubs, The Lamb & Flag, Stockingford and the Royal Oak, Attleborough, are good examples. Those extant today have, in the dim and distant past, obtained licenses to sell wines, spirits and tobacco as well as beer, and in some cases serve food.

Beer was an important commodity and many towns (Nuneaton being no exception) had their own brewery. Like many traditional local industries, the little independent breweries died out, but today it is still possible to buy cask-conditioned ale in superb order locally, if you know where to look. It's a great pity though that many of the pubs you see here in this book have now gone. In fact it is fair to say that most of them are no longer with us, but in some cases the building still remains. Others have been turned over to new uses (such as The Half Moon), while some stand ready for the demolition men to move in with no hope of resurrection as a public house. Most are, sadly, a dim and distant memory.

On the question of comprehensiveness, I cannot be entirely sure that all of the beerhouse names that will follow are a complete list of all that there have ever been in the Nuneaton area. So many were set-up then closed down between census returns, or with hardly a single comment in the history books. Those that we do know the names of, particularly those listed in the Tribune in 1899, have very little information attached to them and in most cases were established then disappeared in very few years of existence at the whim of the proprietor. This has been true across the decades. Pubs set-up within living memory have not been properly locally recorded either, even those that have closed in the last decade, and those your author has visited. Although this is the first local book on this subject, I feel reasonably confident that within weeks of publication new material will come in. It's a popular subject and one which invites further comment and new information.

To set the scene, this article from the *Nuneaton Observer* gives you a contemporary account of the large brewery that once existed in the town.

'The Nuneaton Brewery', by Alfred Scrivener (1845–1886), A Contemporary Account from the *Nuneaton Observer* (1878).

The days of home-brewed ale are fast passing away. Even among farmers, there remain now but comparatively few of the old-fashioned folk who hold it to be an essential article of household thrift that they should brew their own beer. The homely brewing utensils once to be found in every household with any pretensions to liberal house-keeping are fast disappearing, following in the wake of the spindle and distaff which once added to the duties of keeping house the spinning of endless yarns of wool or flax. The tendency of modern industry is to economise the cost of production by effecting in large works, and by one liberal outlay of capital, the labour which was formerly performed by individual households. Where a hundred housewives and their servants were once all greatly exercised in the brewing of a single malt each, the whole hundred strikes are now brewed at one time in one large brewery. By this system there is not only a saving of time and cost effected, but the wealthy capitalist, doing a large and lucrative business, can purchase or command the highest skill to conduct it. The art of brewing the common English beverage is no longer a sort of lucky guesswork

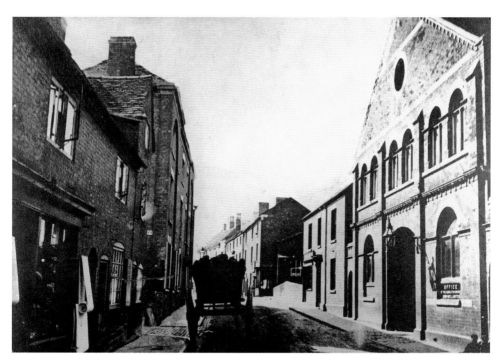

Bridge Street in the 1880s. A very narrow and gloomy defile with the Nuneaton Brewery offices to the right. Debenhams store occupies this site today. Adjacent to the brewery offices was the Brewery Tap and a public house known as the Robin Hood. Note the town bridge over the River Anker just beyond the Brewery. To the left of the cart is Mill Lane which led down to the Flour Mill. The founder of the Brewery business, John Knowles, was also the town miller. The brewery had, at one time, been used as a flour store.

– it has become a science, and the best results are only obtained by scientific accuracy. In the 25 years from 1850 to 1875, the breweries at Burton-on-Trent have increased from sixteen establishments employing 900 hands, to twenty-six breweries employing 4,700 workmen and 350 clerks. The Burton Breweries now produce annually 1,750,000 barrels of ale and porter of the gross values of £4,700,000. In May, 1878, a joint stock company was formed for the establishment of a Brewery at Nuneaton. A manufacturing town, the centre of an important mining and agricultural district, with unequalled facilities of railway communication, and with no brewery nearer than Coventry, it was thought that there was ample scope for the conduct of such a business at Nuneaton on a large scale. So the Nuneaton Brewery Company was formed, and is now in full work.

One of the first conditions necessary for the brewing of good ale is an ample supply of good water of a suitable character. Nuneaton has latterly been canvassing its water supply, and one of the faults found with the water at Nuneaton is its degree of hardness. It also happens that this hardness is one of the qualities most useful in brewing ale that will stand all weathers. The brewers of Burton have the soft water of the Trent flowing close by them, but they do not use it. They draw their supplies from deep calcareous wells, and the principle characteristic of Burton water is its permanent hardness (that is, hardness which is but little lessened by boiling) due to the presence of a high degree of gypsum or sulphate of lime.

The water from an artesian well 228 feet deep, on the premises of the Nuneaton Brewery Company, is found by analysis to possess this quality, and in other respects to be closely analogous to Burton water. A walk round the works of the Nuneaton Brewery Company in Bridge Street, will not be uninteresting among these chapters of Local Industry.

Having first seen the malt being ground, we are shown how it is conveyed by a lift which the workmen call Jacob's ladder, into an upper story of the works. Here it is delivered into a huge funnel-shaped receptacle known as the grist case. It may here be mentioned that at this Brewery the best materials and appliances have been used – the fermenting rounds and unions are all of the best English Oak, and the utensils are all of copper. The mash-tub, which will hold 10qrs. of malt, is flanked on the one side by the grist case, and on the other by the hot liquor back which contains water boiled and kept boiling by a steam coil. The grist passes from the grist case or funnel into the masher, a metal cylinder containing a rod fitted with many spikes, revolving very rapidly. In its passage through this cylinder, the malt, moistened with water, is beaten, crushed, or 'mashed' by the swift revolving spikes, and when delivered in the mash-tub is about the consistency of a rice pudding. The 'masher' used by the Nuneaton Brewery Company is that known as Steels'. The 'mash' stands in the tub for some time to steep, being occasionally 'sparged,' or sprinkled with hot water by means of perforated pipes like those at the back of a watering cart, which revolve above the mash. The boiling water from the hot liquor back then passes through the mash, and the wort, the infusion of malt, is drained off into the under-back from which it passes into the copper. In the copper, which is of sufficient capacity to do all the laundry of a tolerably large village at one time, the hops are added to the sweet wort, and are boiled in the wort for some two or three hours, by means of a steam jacket at the bottom of the copper. From the copper, the wort, in which the sharp acidity of the hop has now tempered the war sweetness of the malt, passes into the well. The 'Laurence's Refrigerator,' used at this brewery is a very ingenious contrivance. The hot wort is made to trickle over a set of hollow pipes, through which a constant stream of cold water is maintained. From the well where it is received after passing over the refrigerator, the cool wort is pumped into the fermenting rounds, large oak vats holding 1,500 gallons. Here the yeast is added and the process of fermentation takes place. After about 48 hours, it is 'cleansed' into the 'pontos' or 'unions,' ten large casks fed by one pipe, and having a swan-neck pipe to each for throwing off the yeast which is received in a trough called the yeast-back. After remaining in the unions about four days, it is drawn into a large square cistern to settle, and is then ready for 'racking' into the barrels for sale and delivery.

The barrels themselves, of which there is always a small mountain piled in the Brewery yard, requires some little care to keep them fresh and sweet. When empty barrels are returned they are first steeped, then washed by means of powerful jets of water driven through the bunghole, and afterwards still more thoroughly cleansed by a jet of steam.

The Nuneaton Brewery Company can at present turn out about 28,000 gallons weekly. The power required in the works is supplied from a 22-ft boiler, working a 16 horse-power double engine. Throughout the works, even a casual visitor would note the excellence of all the fittings and machinery, the cleanliness of the utensils, and the orderly conduct of each department of labour. The whole of the appliances are the most perfect of their kind, and with a supply of water so admirably adapted for the brewing of ale, and the skill

and knowledge which the managers of the Nuneaton Brewery Company can command, there is no reason why Nuneaton should not establish for itself a reputation for good and wholesome ales to equal that of any other town along the valley which feeds the waters of the Trent, not even excepting Burton itself.

Adam Holford & Adams beer products price list from 16 February 1883:

		Barrel	Kilderkin	Firkin
XXXB	Bitter	54s	27s	13s 6d
XXXM	Mild	54s	27s	13s 6d
IPA	East India Pale Ale	48s	24s	12s 0d
XXX	Strong Ale	48s	24s	12s 0d
PA	Nuneaton Pale Ale	36s	18s	9s 0d
AK	Family Bitter	36s	18s	9s 0d
KX	Mild Ale	30s	15s	7s 6d
BS	Brown Stout	48s	24s	12s 0d
P	Porter	36s	18s	9s 0d

The Nuneaton Brewary business was started on 16 October 1878. Extensions to the premises commenced in May 1879. The Brewery itself fronted Bridge Street. However, despite these lofty plans the brewery was not a success and was offered for auction on 6 May 1881, but it did not reach its reserve price. In November 1881 it was purchased privately by Mr Griff Alkin, the Hartshill Quarry owner, but within four months it was on the market again and sold on 11 May 1882. At that time it was bought by a partnership trading as Adams Holford & Adams. Their tenure proved short-lived and within seven years the business was sold on to Samuel Wright of Walkern, who probably gave up brewing on the Nuneaton site at that time and just used the brewery sheds for distribution of their products. On 30 January 1890 the whole site was put up for sale, but again did not reach its reserve price and the brewery was subsequently demolished. The site is now covered by the former Nuneaton Conservative Club and Debenhams Departmental Store. A railway line ran from the station down to the site of the Brewery and entered the premises. It was used to convey flour from the mill close-by up to the station, one or two wagon loads at a time, hauled by horses. The railway line was taken up in the late 1870s, before converting the yard and premises.

It is reasonable to assume that the Nuneaton Brewery was not put out of business for the lack of need in a thirsty working class town like Nuneaton. But, it was instead for the sheer scale of the enterprise, coupled with the ingress of beer from the other breweries scattered throughout the county (with which it was in daily competition)

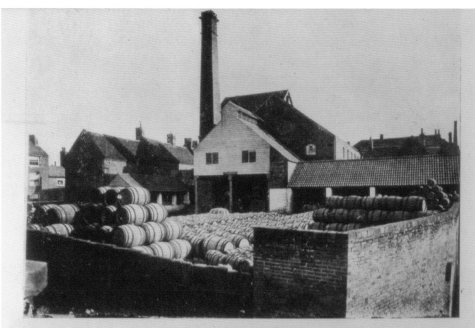

OLD BREWERY.

On the site between Bridge Street and the Conservative Club, and Bond Street and the river, there existed some years a ...ery, all traces of which have now disappeared, with the exception of a deep well at the rear of the premises, from whic ...ly of water for the brewery was obtained. The brewery traded under the name of the "Nuneaton Brewery Company." ...afterwards purchased by Mr. J. Knowles, junr., and was subsequently taken ever by Messrs. Adams, Holford and Co., ...ied on business there for several years. At the expiration of the lease, however, some thirteen or fourteen years ago, ...aises were sold in portions and the brewery taken down. A number of shops with frontages to Bridge Street and Bond S ...exist on the site.

The rear of the Nuneaton Brewery in the 1880s, taken from New Bridge Street.

Pure Ales and Stout.

BREWED WITH WATER FROM ARTESIAN WELL.

The Exors. of SAMUEL WRIGHT,

VICTORIA BREWERY, WALKERN, HERTS,

Having Purchased the Business heretofore carried on by Messrs. ADAMS and Co., at the Nuneaton Brewery, will henceforward conduct same as an AGENCY, and respectfully request that all ORDERS may be Addressed to their Manager,

Mr. W. F. ADAMS, at the Brewery, Nuneaton.

The subjoined analysis proves that the Beers supplied are perfectly pure and of exceptional quality.

Laboratory : Gresham House, 24, Holborn Viaduct, London, E.C., May 17th, 1886.

Dear Sirs,—I have carefully analysed the sample of ale you have submitted to me with the following results:—

					PER CENTAGES.
ALCOHOL (PROOF SPIRIT)	8·60
MALTOSE	1·10
DEXTRINE	1·32
ALBUMENOUS MATTERS	0·71
ASH	0·64
HOP EXTRACT	1.52

The Ale is very brilliant, of excellent flavour, and possesses that sparkling condition so much desired by the consumer. I have carefully searched for the presence of deleterious substances, such as lead, copper, Etc., with the result of proving only their complete absence ; the very low acidity (0·095 per cent.) renders your ale peculiarly digestible and suited to invalids. I consider that you have produced a beverage of excellent quality, and one which from its purity, should command a large and ready sale.

I am, yours faithfully, LAWRENCE BRIANT, F.C.S.,

Author of the Laboratory Text Book for Brewers.

To the Executors of S. WRIGHT, Walkern Brewery.

and the well-known beer brewing towns immediately beyond. Leamington, Coventry, Lichfield, Northampton and Burton-on-Trent were major suppliers of beer sold locally, on top of this there were small brewery and pub brewery operations in the immediate vicinity. Several pubs brewed their own at the time and there was even a brewery in Bedworth (Dewis') that produced beer and ale. So the production far outstripped demand and it is not surprising that after only a few years the Nuneaton Brewery went out of business. It was eventually taken over by Samuel Wright's Walkern Brewery and brewing ceased at Nuneaton. Wrights distributed ale only to the public houses who were formerly customers of Nuneaton's brewery.

OTHER LOCAL BREWERIES SUPPLYING THE NUNEATON AREA IN THE NINETEENTH AND TWENTIETH CENTURIES:

Bedworth Brewery – Proprietor was Thomas Dewis (in business 1893–1924). The Rye Piece, Bedworth.

Spencer's Rock Brewery – Old Church Road, Foleshil. Michael Spencer (in business *c.* 1880–1913).

Phillips & Marriott – Coventry. In business 1868–1924, taken over by Bass Ratcliff & Gretton of Burton on Trent.

William Ratliff, The Coventry Brewery – Leicester Road (in business 1850–1900 when it amalgamated with Phillips and Marriott).

Ratliff's tied estate in the nineteenth century included:

King William IV, Hartshill.

Lewis Haddon & Arkwright – succeeded by Lucas Blackwell & Arkright, The Leamington Brewery, Lillington Avenue, Leamington Spa (1836–1934), taken over by Ansells (the Birmingham brewer).

The Leamington Brewery had a large tied estate and their Nuneaton pubs in 1885 included:

The Bull Inn, Attleborough – Tenant was Thomas Smith. Rent £24 a year.

Holly Bush, Nuneaton – Thomas Fortescue. Rent £18 a year.

Crown Inn, Nuneaton – Titus Robottom. Rent £20 a year.

White Hart, Nuneaton – W. Trinder. Rent £21 a year.

Plough & Ball, Nuneaton – Elizabeth Cox. Rent £14 a year.

Midland Railway Inn – James George. Rent £30 a year.

Weavers Arms, Nuneaton – Andrew Bull.

Crystal Palace, Nuneaton – George Tyler.

Castle Hotel, Nuneaton – F. W. Williamson. Rent £48 a year.

White Swan, Nuneaton – Joseph Bradbury. Rent £18 a year.

Flower & Sons Ltd of Stratford upon Avon were the largest brewery in Warwickshire (1785–1968). The Flowers brand lives on and is available in Whitbread pubs today.

Ansells Brewery Ltd, Aston, Birmingham (1858–1961), now part of Allied Breweries.

James Eadie & Co. Ltd, Burton upon Trent (1854–1933), acquired by Bass.

Bass Ratcliffe & Gretton Ltd, Burton upon Trent, (1877–present).

Phipps Northampton Brewery Co Ltd, (1801–present).

Marston, Thompson & Evershed Ltd (1834–present), now the largest brewery business in the world.

Atkinsons Brewery Ltd, Birmingham (1878–1959), sold to Mitchells & Butlers Ltd.

Samuel Allsopps & Sons Ltd, Burton upon Trent (1807–1959), sold to Ind Coope Ltd.

Leicester Brewing & Malting Co. Ltd (1890–1952), sold to Ansells Brewery Ltd.

Thomas Salt & Co. Ltd, Burton upon Trent (1774–1927), taken over by Bass Ratcliffe & Gretton Ltd.

Burton Brewery Co. Ltd, Burton upon Trent (1842–1915), taken over by Worthington & Co. Ltd.

Worthington & Co Ltd, Burton upon Trent (1915–1927), taken over by Bass, Ratcliffe & Gretton Ltd.

Offilers Brewery Ltd, Derby (1876–1965), taken over by Charrington United Breweries Ltd.

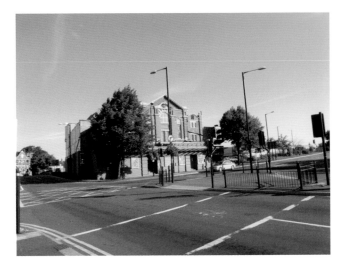

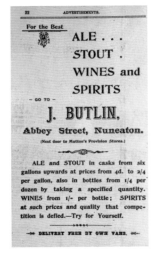

Above left: For some years Nuneaton had another small brewery housed in this building that had, over the decades, a complicated number of uses and still exists in 2015 as a gym and fitness centre. It started life as the Empire Theatre and was at one time a bus garage, a car garage, a bakery, a furniture warehouse, a factory for making springs and for about fifteen years a nightclub, with a small bar attached that was used as a small home brew brewery. The nightclub closed and the building now houses a fitness centre. The Crown Inn can be seen in the distance down Back Street.

Above right: When John Butlin retired in 1881 as goods agent at Nuneaton after twenty years' service on the London & North Western Railway, he continued to supply ale under his own name, adding to the vast quantity of beer entering and being brewed in the town. The place was awash with the stuff.

Central Nuneaton

ABBEY STREET

The most populous street in Nuneaton was Abbey Street, which contained two thirds of the population of the town before 1880. As a result, at one time or another, virtually every other block of buildings had beerhouses or fully licensed pubs in them. In addition, behind the house fronting the street, there were many blocks of poor tenements containing hundreds of cottages cluttered around small, damp, insanitary yards, known locally as 'courts'. By 1930 one in ten houses were classified as unfit to live in. Most of these were in Abbey Street. A slum clearance programme started in 1938, by 1939 there were 536 old properties that had been demolished, mostly on Abbey Street. It was not badly affected by war time bombing, rather it was the two streets adjacent, Abbey Green and the Manor Court Road, that were the most damaged. Demolition continued through the 1950s and '60s until hardly any of the old buildings remained.

Here is a list of all of the known pubs and beerhouses that once existed. Most of these disappeared with slum clearance. It makes you wonder how much beer was consumed back then that justified the level of business. There were at one time two Rams, The Old Ram, in the Market Place, a very old pub believed to date back to the time of Nuneaton Abbey. The New Ram in Abbey Street (later renamed the Wellington and later still, the Pig & Whistle) was extant before 1847 when the license was transferred from John Sanders to Thomas Grove. William Clarke was the publican at the New Ram in 1863, followed by: Charles Windridge in 1868, Joseph Moreton in 1872–1880, Thomas Underhill in 1884 and 1892, 1896 Arthur Townsend in 1896, Arthur Dowell in 1900, and Thomas Jeffcote in 1904. The building we see today is not the original, there were once three individual houses (Nos 97, 98, and 99) on this site and the pub only initially occupied one of them. It seems to have been rebuilt at some stage during the nineteenth century. By 1912 it had been named the Wellington Inn, with John Stringer listed as its landlord. Other landlords were Joseph Olner in 1921, A. Suffolk in 1926, James Frederick Ison in 1928, C. A. Cross in 1933, then Charles Alan Cross between 1934–1940. Today, the former Wellington pub is a stove shop.

The Wellington. (Colin Yorke Collection)

As you can see from this view, the Wellington was overshadowed by the Ritz cinema and its proximity made it a favourite watering hole for those visiting the pictures. When the last film was shown on 18 June 1984 the Wellington's trade would have been affected and despite the Ritz continuance as a Bingo Hall, the clientele were generally not the sort to resort to the pub afterwards for a pint.

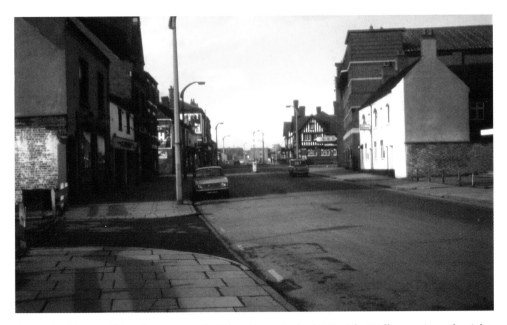

A view looking up Abbey Street towards Abbey Green in the 1970s. The Wellington is on the right.

The Plough and Ball (now Town Talk), No. 11 Abbey Green

This derived its name from two old pubs – the Old Plough in the Market Place and the Golden Ball. The Old Plough was closed and demolished in 1845, the site later became Iliffe's, the chemist, on the corner of the Market Place and Bye Corner or, as we know it today, Newdegate Square. The Plough's license was combined with the equally ancient Golden Ball, an old pub on Abbey Green that occupied the site of the 'modern' pub – The Town Talk. The original Golden Ball was said to date back to the eighteenth century, but the building looks older from photographs. It was once a favourite retreat for cock fighters and bull baiters when there was a bull ring on Abbey Green; the iron loops for tethering bulls were a feature of the area in the early nineteenth century. The Plough & Ball was kept by William Cox in 1850 and Tom Willoughby was the publican in 1900. His widow was the tenant in 1912. An unfortunate incident befell the pub during substantial alterations in 1904 – it suddenly collapsed. The ceilings were being raised because they were only five or six feet high, the restricted height must have been a considerable inconvenience to the pub's customers if you had to crouch to get in. Quite how they expected to carry out this work in view of the pub's age and rickety condition, I am not sure. Not unexpectedly, the worst happened. The building was so fragile that the process of raising the ceilings brought the whole pub crashing down in a pile of bricks, dust, timber and thatch. Two workmen were injured and had a miraculous escape, including one Nuneaton footballer, Mr A. Lee, who was due to play for the club against Handsworth the next day. Needless to say he could not make that match. The pub was then entirely rebuilt as a modern tavern and renamed the Town Talk some years ago. Fred Carris was the landlord between approximately 1933 and 1939. The Carris family had strong family links with local football.

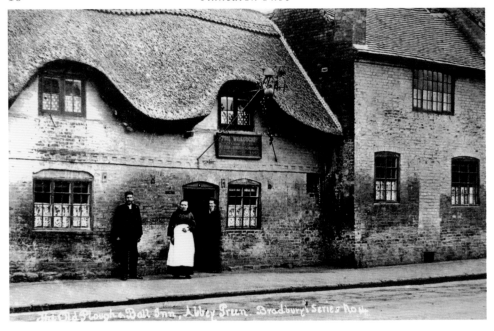

In 1904 The Old Plough and Ball Inn was said to be the oldest pub in Nuneaton. Tom Willoughby was the landlord, seen here.

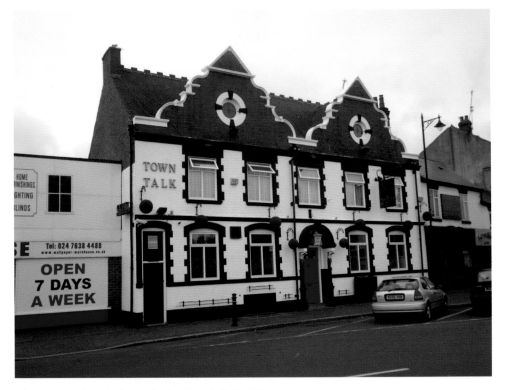

The Town Talk pub (formerly the Plough & Ball) in modern garb.

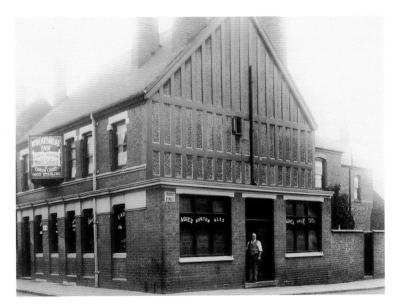

The second Wheatsheaf Hotel with the publican Samuel Arnold (1858–1941) at the doorway. Sam married Emma Cart and had eight children. Sam and one of his sons (Tom) was killed in the great Blitz on Nuneaton in May 1941. Over 130 people were killed and many properties locally were badly damaged.

1. The Wheatsheaf Hotel, No. 36 Upper Abbey Street

The Wheatsheaf was not listed in 1806, although it can be dated back to before November 1825 when it belonged to a Mr Lingard. It was occupied by John Randle and other tenants in 1828–1841, then in 1841 it was sold for £600. William Craner was the landlord in 1850, in 1896 it was A. J. Merry, Sam Arnold was the tenant in 1912, and George Warren was the landlord in 1933. The Wheatsheaf was rebuilt around 1900 to the pub we see here, this later building was demolished over the course of July and August 1963. A new modern pub took its place on the opposite corner of Priory Street, although this subsequently closed and has now been let as a shop premises.

The Bush

The licensed victualler's returns for 1806 provide us with the name of this pub and state that William Taylor was the proprietor at that time. However, its location in Abbey Street, as so many of these old licensed premises, is not known for certain. It does not seem to have lasted until the middle of the nineteenth century and the exact date of closure is not recorded. The name probably does not relate to a piece of vegetation of the woody/leafy variety, but more to the preference of old Nuneatonians who thought if they had woken up in the morning with a good 'bush' or 'thick head' it seems to have given them some satisfaction that they'd had a good night out the evening before!

2. The Coach and Horses, Nos 86–87 Abbey Street

For most of the first half of the nineteenth century (certainly between 1806 and 1850) this pub was owned by the Hastelow family. In 1867 they still seem to have the freehold, but sold it in September that year, although John Mills was the licensee at that time. At this point it had its own brew house. It was later sold to the Lichfield Brewery and was then owned by the Flowers (of Stratford on Avon) Brewery during the early part of the twentieth century, before becoming an Ansells pub. Mr T. E. Woodcock was the tenant in 1912 and A. Tinsley

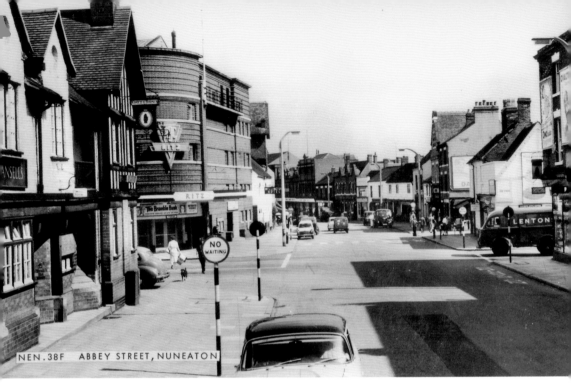

The Coach & Horses is the Ansells house (shown on the left in this photograph) of Abbey Street, looking towards the town centre. The Ritz cinema is beyond and High Street off to the right. The photo dates back to the 1950s.

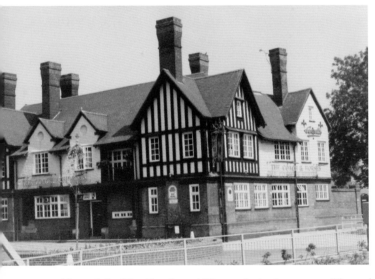

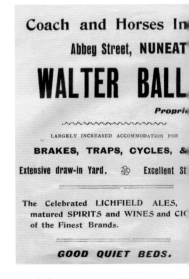

Above left: The Coach and Horses in its last years. The pub is boarded up now (in 2015), derelict, and may not last much longer as the site has been earmarked for redevelopment. (Credit – Colin Yorke Collection)

Above right: Walter Ball was the tenant in *c.* 1900.

was there in 1933. In recent years its name was changed to the Kingsholme, but the pub has stood derelict and has been threatened with demolition since the closure. There has been talk of the site being used for a petrol station but those plans appear to have been shelved.

3. The Abbey
An 1830 beer shop, James Adie was the beer seller. It stood on the site of Frederick Bostock's butchers shop in 1899 at No. 7 Abbey Green.

4. The Horse Shoes
This beerhouse was near the entrance to the Burgage Walk. It was licensed in 1806 and J. Wilson lived on the premises in 1899. This Horse Shoes is not to be confused with the Horse Shoes at Chilvers Coton, with which it was contemporary.

The Three Tuns
In 1806 the licensee was Richard Hawkins. In January 1827, Nuneaton Diary records 'The Three Tuns, public house in Abbey Street with three tenements adjoining put up by auction and bo't in about £1250'. John Vernon was listed there in 1828, 1835 and 1841. In 1850, Joshua Siddall was tenant and the property was owned by William Vernon. It was placed on the market again in August 1851 in four lots. The property was extant as a private home in 1899.

The Gauze Hall
This was originally a large warehouse, built in the heady days of the gauze ribbon trade at the beginning of the nineteenth century as warerooms for the wholesale ribbon dealers and traders known as Hood & Ward of Nuneaton and Bethnal Green. The gauze ribbon fashion rapidly died out and the large premises were put to other uses, including a pub by the 1850s. The landlords were James Thorne in 1851 followed by John Haynes. It was later converted to a Baptist Church, which later relocated to a fine purpose-built church in Manor Court Road during 1899. By 1900 it had become branch factory premises of Pool Lorimer and Tabberer, a subsidiary of a Leicester business specialising in babies and children's ware, in addition to ladies' outer undergarments etc. The factory burnt down in a spectacular fire on 20 April 1928 and the site stood derelict for about forty years.

The Exhibition
The location of this is where Mr T. Tullett's shop stood in 1899, it was directly next-door to the Coach & Horses pub. George Wood was the original beer seller. It was opened in 1851 to celebrate the Great Exhibition. I have no information as to how long it traded.

The Royal Oak

Higher up Abbey Street on the same side (as the Rose & Crown) was the sign of an inn probably more ancient than its name. It is a low mean dark building, but the quaint corridors and intricate passages at its rear might be contemporous with that memorable tavern the Tabbard at Southwark, whence Chaucer's merry company started on their

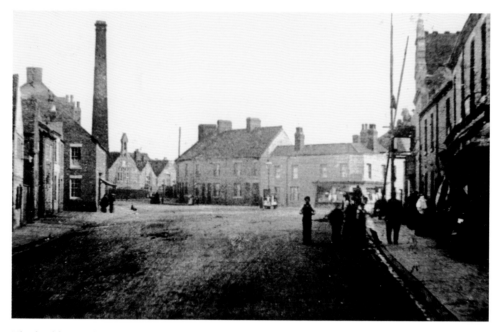

The building still stands, seen here behind the people in the roadway, but in 2015 it is much altered externally.

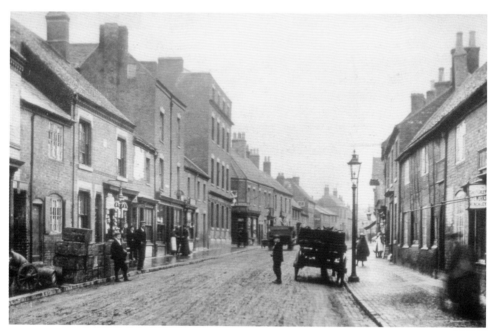

The Gauze Hall was the four-storey building in the centre of the photo that stood on the corner of Meadow Street. A Leicester hosiery company (called Poole Lorimer & Tabberer) owned the building until it burnt down in 1928 from a spectacular fire caused by an electrical fault. (Reg Bull Collection)

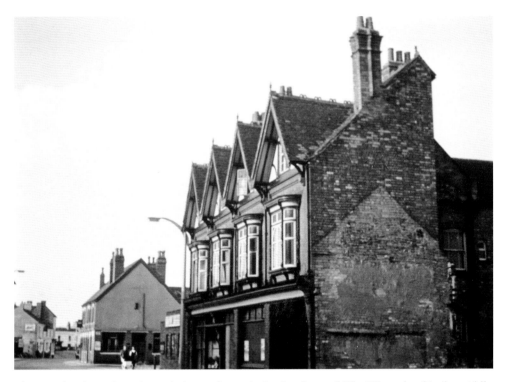

The Royal Oak on the right with three other pubs in view beyond. The Wheatsheaf in the middle distance, the Oddfellows Arms on the extreme left and both of these latter pubs frame the former Abbey Beerhouse. The imprint of demolished buildings can be seen on the end wall. (Credit – Arthur Tooby)

> immortal pilgrimage. please my wayward and credulous fancy by supposing that this tavern close to the Abbey Gates, was frequented of old by pilgrims and jolly friars, by chapmen and devotees, whom business or devotion brought to the venerable pile.
>
> Alfred Scrivener (1877)

This picture of words from Alfred Scrivener is all that we have of the Royal Oak. In the nineteenth century it was entirely rebuilt, then its Victorian replacement was also demolished in September 1960 along with many of the old properties that once fronted Abbey Street. William Taberner was the tenant in 1835, W. H. Albrighton in 1896, T. H. Trinder was the landlord in 1912, and C. B. Scattergood was the landlord during approximately 1933 and 1939. When Cyril Scattergood kept the pub, he had a pet badger in the stables at the rear. This was a big draw at the weekend when families turned up to watch the antics of the animal; parents enjoyed a glass of real ale, the kids a glass of pop.

Shepherd & Shepherdess
This is where Dr Vaughan lived in 1899. James Biddle was the original beerhouse owner.

The Paul Pry

This was an 1830 beerhouse on Abbey Street. It was named after a popular American song that was published in 1820 and must have become popular in Nuneaton ten years afterwards. Paul Pry was described as an inquisitive character prying into people's affairs. The property was located just above the former familiar chemist shop, Ranby's, which stood on the corner of High Street and Abbey Street. David Smith was the original beerhouse keeper when it first opened; it must have closed by the mid-nineteenth century.

Seven Stars

This was on the site of the Tribune buildings (next-door to the Bull's Head, now the India Red Indian Restaurant). It was an 1830 beerhouse. T. Johnson kept it at one time, but precise dates are not available and it may have moved site (see below).

New Seven Stars

The new Seven Stars is possibly on a different site to the previous beerhouse (above). Elizabeth Staine was the landlady. Whether this replaced the original Seven Stars is not known, or if there was any connection between the two properties.

Cross Keys

This was next to the Half Moon. Mr John Smith purchased newly built premises at the back of the Half Moon for £350 in August 1817, he later opened it as the Cross Keys beerhouse. The property was occupied by a Mr J. Smith, a coal dealer, in 1899.

The Fox

Mr John Bell (landlord) doubled as the driver of the mail coach to Birmingham. He also rented a field in the Abbey Meadow in Meadow Street. The former site of this pub is assumed to have been near to Meadow Street.

The Shipwrecked Sailor

Another 1830 beer shop. We know nothing of its history and it probably did not last long enough to be remembered by the local Victorian historians.

The Britannia

This is where Messrs Wilkinson's furniture premises used to be (near No. 117). It was not listed in 1806. Former publicans were John Dance (1828), Joseph Haddon (1835) and Thomas Winter (1841).

5. The Odd-Fellows Arms

The 'oddies' as it is popularly known, was the last traditional pub in Abbey Street to survive unchanged. Opened in the 1880s by Levi Munton (1852–1898). Mr Munton's occupation was also listed as a brazier, gas-fitter, ironmonger, cycle dealer and bell-ringer. A. Bray was the landlord in 1901, followed by G. H. Jeffcoat in 1912, then E. Sutton was there in 1933, and J. H. Lucas was the landlord in 1938–39. This

The Oddfellows has been converted into an Indian Restaurant, it is the white building in the centre of the picture, seen in context of Upper Abbey Street where its roadway starts on the corner of Meadow Street to the left. This photo was taken from Abbey Strret.

pub is now a restaurant and survives in its original premises. I expect the name of the pub was derived from the Independent Order of Odd-Fellows, a Friendly Society, and adapted as their meeting house. It was a Salt's pub.

The Bull's Head

During 1806–41 the license was held by the Robottom family (Samuel, James and Samuel). In 1863 Sarah Ball was the licensee. At one time it was owned by the Nuneaton Gas Company, it was sold by them on 29 September 1893 to James Eadie & Co. Former tenants were listed as George Randall, Thomas Buckler and William Ratcliffe. For some years it was headquarters of Nuneaton Town Football Club. On 5 February 1986 it was sold to Bass Holdings Ltd. The landlord at the time was S. Bradbury. The pub had a reputation for being haunted; a former landlord told the author that he saw an old lady come from behind the bar and walk through the wall out into the street! R. Brown was the landlord in 1933.

6. The King's Arms

Many of Kings Arms customers were workers at the Hall and Phillips factory, located at the rear with a direct connecting footpath. The path was closed one day per year to establish Hall & Phillips' private right of way. As Hall & Phillips employed between 300 and 400 people in the early 1900s, trade must have been pretty brisk. Former landlords include William Congreave (1806), John Grove (1850), T. Petty (1896), Andrew Mawbey (1901), James Wilson (1912), and retired policeman Pat Molloy (1920s and early '30s). There was a swimming pool at the rear of the pub that had

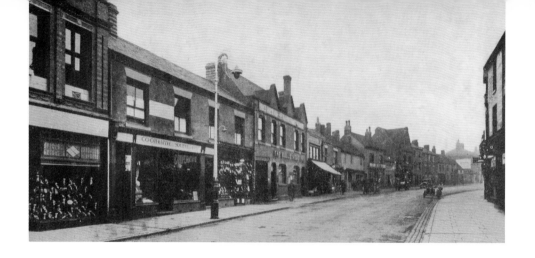

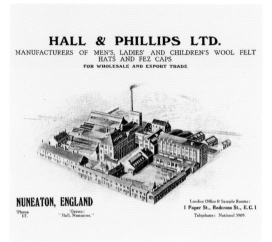

HALL & PHILLIPS LTD.

MANUFACTURERS OF MEN'S, LADIES' AND CHILDREN'S WOOL FELT
HATS AND FEZ CAPS

FOR WHOLESALE AND EXPORT TRADE

NUNEATON, ENGLAND

'Phone
17.

'Grams:
"Hall, Nuneaton."

London Office & Sample Rooms:
1 Paper St., Redcross St., E.C.1
Telephone: National 3909.

The Bulls Head in 1928. (To the right of the lamp post at centre of the page, with three gable ends). It is surprising that the premises survive today. It has been reprised in its new role as a fine Indian Restaurant, where you can still drink a pint or two if required. The Co-op store is creeping up to it. (Credit – Reg. Bull Collection)

Hall & Phillips factory backed on to the Kings Arms and provided most of its trade. Hall & Phillips went out of business and these extensive premises were then turned over to other uses, including the manufacture of timber dashboards for cars. A fire started here on 16 December 1967 and devastated the old mill premises.

formerly been a malt house and was, in effect, Nuneaton's first swimming bath. The pool was later drained and boxers used to train there in the 1920s and '30s. Pat Molloy was the tenant in 1933 and Edward Hutt was the landlord in 1938–39. Mr Hutt was previously the publican at the Crown in Bond Street. The Kings Arms closed in the 1950s or '60s. The last licensee was S. V. Harvey.

The Weavers Arms
The Weavers Arms took its name from the principal trade of the town – silk weaving. Tenants were Thomas Griffin (1828), Joseph Taberner (1835), William Green (1841), James Wheway (1850), Seymour. Bull (1896 through to at least 1912), H. S. Bull (1933), and C. Mann was the landlord in 1938–9. It is a still open as a public house under a different name today, one of only two pubs to survive in Abbey Street.

The Half Moon Inn, No. 112 Abbey Street
In 1896 the tenant was W. Bell and by 1912 it was Herbert Davis. The landlord in 1933 was J. Knight.

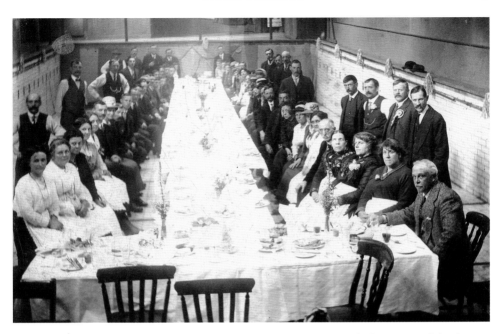

While we do not have a very good photo of the Kings Arms, we do have one of the former swimming pool at the rear. Here it is drained and in use as a venue for a luncheon of some kind. Full of the great and good of old Abbey Street. The swimming pool had started out as a malthouse as part of the Kings Arms' home brewery and was latterly used as a swimming pool, which could be given over to boxing matches and, as seen here, other local functions.

The Weavers Arms on the right (1950s) with the old Wesleyan church and the Liberal Club on the corner of Stratford Street beyond. Both were not promising sources of customers for the pub, being frequented by members of the Methodist persuasion who were not known to be great drinkers. (Credit – Reg. Bull Collection)

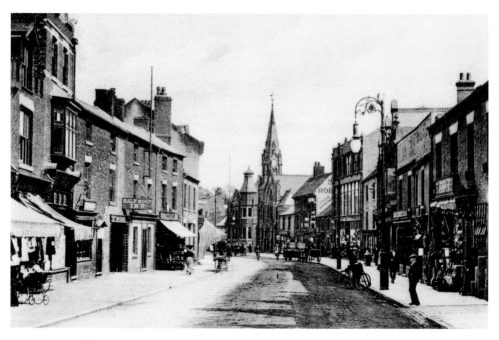

A later view of the Half Moon Inn on the left, not long after 1900. You can see how this aspect of Nuneaton has changed.

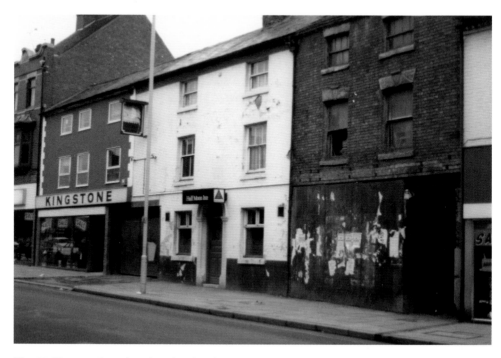

The Half Moon has closed and redevelopment is due to take place (at the time of writing). The building survives, but is now a shop. The derelict building on the right next door has been demolished and rebuilt.

MIDLAND ROAD

7. The Bowling Green (later the Midland Railway Inn)

The Bowling Green was an early nineteenth century pub, although the exact date it opened is not known, it was sometime after 1806. It was certainly in business by the 1840s. It was situated on the corners of Midland Road, Abbey Green and Manor Court Road. David Ensor was the licensee in 1896 and H. K. Brown in 1912. The pub was destroyed by the Luftwaffe on the night of the Blitz in May 1941 and its license was immediately transferred to a former private house in Princes Street – The Harcourt, home of one of the local victualing Taylor's, Harcourt Taylor (see the Harcourt later on for details). The Bowling Green used to be an Ansells pub, but it had originally been a tied house of The Leamington Brewery and part of their tied estate was sold to Ansells. S. Morgan was the landlord in 1853. In 1885 the landlord was James George who paid £30 a year rent. The landlord in approximately 1933–39 was H. J. Knight.

MEADOW STREET

The Bell

In 1830, Joseph Bacon held a beerhouse in his property in Meadow Street, it was still extant in 1841 when the address was given as The Bell Inn, Abbey Meadow, in the census. There are connections between this Bacon family and Mary Ball, the last woman to be publicly hung in Warwickshire in 1849.

NAVIGATION STREET (MIDLAND ROAD)

The Black Horse

This is the Black Horse on Midland Road, not to be confused with the other Black Horse pub in Wheat Street that was demolished in the 1950s, known as 'the noted badger-baiters house'. The Black Horse in Midland Road was an 1830 beer shop.

PRINCES STREET

The Rose and Crown

This ancient property was occupied by Mr W. Green in 1899, a local builder. Benjamin Rayner was landlord between 1806 and 1841. In November 1877 Alfred Scrivener, editor of the *Nuneaton Observer*, gave it the following description:

> The Rose and Crown in Abbey Street, though probably old at least as the times of Good Queen Bess, is changed into a plain and comfortable private house. It is a remarkable well preserved example of the old half-timbered English dwelling. The Rose and Crown in more modern days is chiefly remarkable because its landlord, Mr Benjamin Raynor, who cracked his last old fashioned joke more than twenty years ago, for thirty years united his general duties as mine host, the office of English Master at the Grammar School.

The Pheasant Inn, No. 5 Abbey Street

Sarah Varden was the licensee in 1841 and 1850. Later occupiers were Roland Till, also a blacksmith; Joseph Liggins, who was there in 1912; and Horace Warmington, brother of Louis Warmington, the fruiterer in Queens Road. The last licensee was H. J. Fallows when the pub closed on 6 September 1934. The license was then transferred to the Weddington Grove, a former private house in Weddington Road.

Abbey Gate Refreshment Rooms, Abbey Gate

This was licensed to solely sell beer and was located where the American (or Colonial Meat Shop) was in 1899. The proprietor was Mr John Argyle, who was one of Nuneaton's pioneering photographers.

STRATFORD STREET

The Felix Holt

This is a modern Wetherspoon pub, purpose built on the site of Smith's (the undertaker). It was named after a well-known George Eliot novel.

Yates Wine Bar

Yates Wine Bar, which stood opposite The Felix Holt in Stratford Street, was not a success and closed in 2008.

TUTTLE HILL

8. The White Horse

This was a former canal inn. After being used as the Crazy Horse and also a Chinese restaurant, it is derelict today. Thomas Cox was the landlord in 1835, the tenant in 1912 was P. V. Lewis, R. Shelmerdine was landlord in 1933, and F. Wale was the landlord in 1938–39.

9. The Punch Bowl, No. 7 Tuttle Hill

The Punch Bowl was closed in 1950 to remove an awkward bottleneck when the canal bridge was widened. A Bass House, the license was transferred to a new pub by that name further up Tuttle Hill. Licensees included Francis Harrison (1806), John Cotton (1828), John Cotton (1835), Samuel Warren (1841), it was tenanted by a Mrs Lee in 1912, F. Warner was publican in 1933, and A. Harris was the landlord 1938–39. In 1877 Alfred Scrivener, the former and founding editor of the Nuneaton Observer, wrote 'While the Market place was excited by the dashing glories of the mail coach, curious groups would gather at times on the Punch Bowl Bridge to watch the passage of the packet or the flyboats'.

The White Gate Inn

This was formerly a cottage near the Windmill on Tuttle Hill, kept by Thomas Lees. It bore the inscription 'This Gate hangs well upon the trees, call and drink at Thomas Lees'.

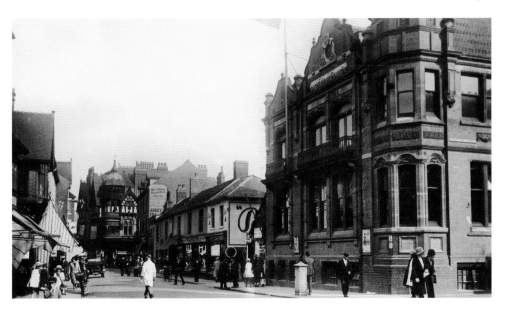

The bottom of Abbey Street in the 1920s. The pub occupied the buildings on the right, just to the right of the man with the white coat in the image.

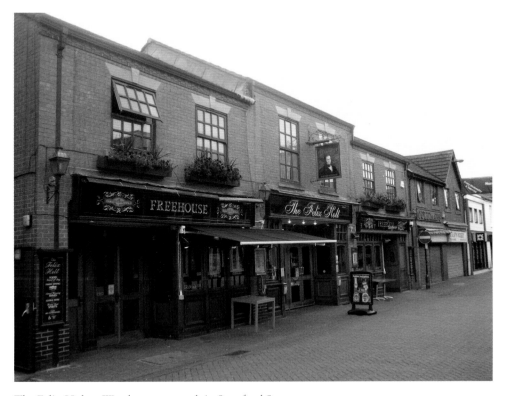

The Felix Holt, a Weatherspoons pub in Stratford Street.

The White Horse, on the left, looking up Tuttle Hill.

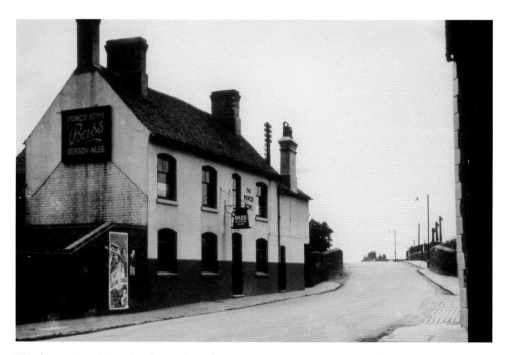

The former Punch Bowl pub stood on the main A47 Nuneaton–Birmingham road as it climbed towards Tuttle Hill. Here it is looking towards Nuneaton town centre in October 1950, awaiting demolition. You can see here the reason for its demise. The road over the Coventry canal was not wide enough for 1950s traffic, although the railway bridge beyond did not need widening. The wall on the right is that of the White Horse, which in 2015, still stands. The pub had to come down in order to realign the road and create sufficient road width. (Credit – Reg. Bull Collection)

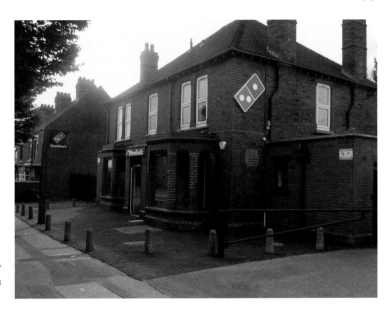

Premises of the new
Punch Bowl, now a
pizza outlet.

The Windmill Inn

A house occupied in 1899 by Thomas J. Chinn. It was formerly kept by William Croshaw in 1815 until an unknown date; Cordwainer from 1879, the grandfather of one of Nuneaton's mayors, Walter Croshaw (mayor from 1937–39).

NEWDEGATE SQUARE (FORMERLY BYE CORNER)

10. The Black Bull, which became the Newdegate Arms Inn in 1816

The Newdegate Arms was known as the Black Bull Inn until its name was altered to 1816. In 1801 the landlord was Joseph Bostock. It used to be a commercial and posting house, later the Midland Railway adopted it as their hotel for travellers taking a break in their journey at Nuneaton. Work began in 1914 to build the new Newdegate Arms Hotel, which was in turn demolished in 1963. The redevelopment of the original Newdegate Arms site due to road widening cost £8,250. Former tenants were Thomas Winfield (1828, 1835, 1845), Thomas Bills (1863), and Joseph Bostock was the landlord in 1901. In the middle of the nineteenth century a magistrates meeting was held here every Saturday. The magistrates who originally attended were the Revd. Samuel Bracebridge Heming (chairman), Sir John Newdegate Ludford Chetwode (baronet), and the Revd James Corrall Roberts. Mr Henry Power was the clerk of the court, and the chief constables of the parish were Joseph Haddon and Abel Brown. It was not a very satisfactory arrangement since you could often find the magistrates, constables and defendant, as well as the local labouring classes, all drinking at the same bar! The new law courts were opened in Coton Road in 1899 and this remedied the problem. The hotel became a part of the Trust Houses Ltd chain. The landlord in 1912 was Thomas John Lilley (or Tuddy Lilley to his friends).

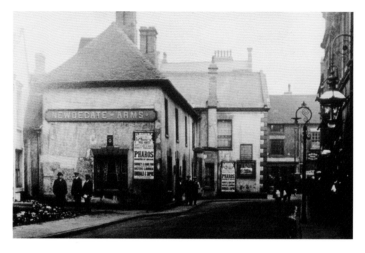

The Newdegate Arms was a complex building: a collection of old structures that had been added to over centuries. The pub was one of the two principal hotels in town, the other being the Bull in Bridge Street. (Credit – Reg. Bull Collection)

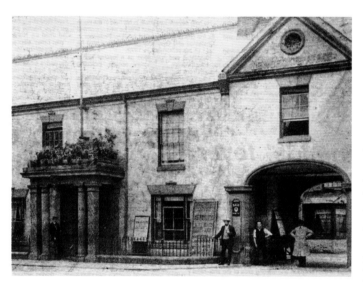

This entrance faced Newdegate Street. Mrs Lilley would suspend legs of mutton or beef under the archway to entice guests to lunch with her in her fine dining room. Mrs Lilley's trifles were well-known for the large amount of sherry added to them. The hotel was the magistrate's court as well, until the police court opened in Coton Road in 1899. A bone-setter attended here one afternoon each week to deal with the tricky requirements of setting the broken bones of local people who had been injured during the previous week.

Newdegate Arms Hotel
Nuneaton

TARIFF
1963/1964

	Room and Breakfast
Single room	£1 15 0
Double room	£3 0 0
Luncheon (3 courses)	9/6
Afternoon tea	4/6
Dinner (3 courses)	10/6
EXTRAS Early morning tea	1/6
Coffee after meals	1/0
Service of meals in bedroom	2/0

TIPS 10% will be added to hotel and restaurant bills and this will all be distributed to the staff in place of gratuities

NOTE Inclusive terms are not offered

Special rates are charged at Christmas
The terms quoted are subject to revision without notice

A TRUST HOUSE HOTEL

Newdegate Arms Hotel
Newdegate Street **Nuneaton** Warwickshire
Telephone Nos. Reception 3656 Visitors 3657, 4777

The present Newdegate Arms replaces a much older house at one time known as the "Black Bull". Recently the public rooms were remodelled and refurnished and the dining room enlarged. The Hotel is in the centre of the busy manufacturing town which has grown around the market square. It is the "Milby" of George Eliot's novels in which the Newdegate Arms figures as the "Oldinport Arms," and is a place of pilgrimage for her admirers. There was a fine Assembly Room in the inn of her day, and the modern Hotel has excellent accommodation for functions. Arbury Hall, seat of the Newdegate family, is open to view on certain days during the summer.

A TRUST HOUSE HOTEL

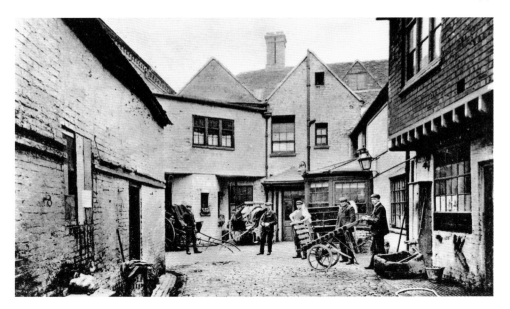

The Newdegate Arms yard.

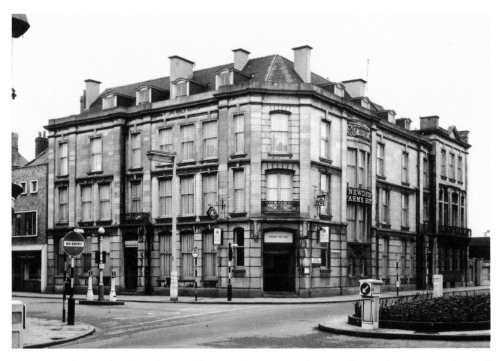

In 1914 work started on demolition of the Newdegate Arms (shown in the previous pictures) for road widening. The cost of the work was stated to be £8,250, but the start of the war slowed things down considerably and it took several years to complete the new hotel seen here. It caused financial difficulty to Mr Lilley despite the fact that the local council were funding the project. Lack of skilled labour as men joined the army was the problem. Nevertheless, when the new hotel opened it was a fine building and served the town as its premier inn for nigh on forty years. (Credit – Reg. Bull Collection)

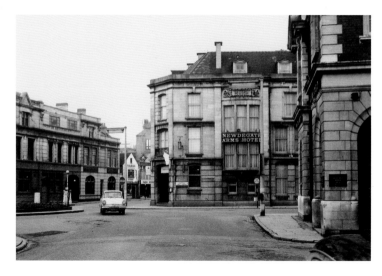

The view here looks back towards the Newdegate Arms from Newdegate Street. The Ford Anglia has come out of Abbey Street. (Credit – Reg. Bull Collection)

The Fox

John Bell kept a beerhouse called the Fox. The location of this pub has not been established.

The Woolpack

This beerhouse was situated where Debenhams now fronts Newdegate Square.

NEWDEGATE STREET (NEW BRIDGE STREET)

Dog and Partridge

This was the only known beerhouse in Newdegate Street. The 1899 article of extinct public houses listed it as being occupied at the time by Mr Swann's clothiers. Elizabeth Wray was the proprietor while it was a beerhouse.

BOND GATE, BOND STREET, FORMERLY BOND END AND BLIND LANE

11. The Crown Inn

I was born in the Crown Yard, Bond Street, now happily demolished and I still marvel, when crossing the river bridge at this point, however, 10 houses, a workshop and a bowling alley could have been on the site but it was so. I have referred to the bowling alley, the last open air alley in Nuneaton, I believe. Here there used to be trundled great bowls at great skittles, the only break being copious swigs of ale from the gallon jugs in use in those days. The ale was 3d. Per pint, and it was ale!! I remember the custodian of the Crown. Mr Rowbottom and his two goliath sons – Titus and Fred. Good kindly chaps. I often wonder what has become of them?

Mr A. E. Jebbett, former editor of the *Midlands Counties Tribune* (1955).

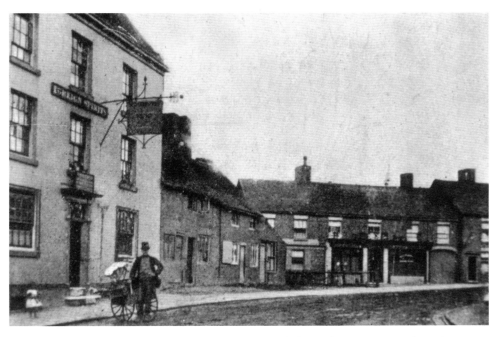

This is the Crown Inn as it appeared in the 1880s, with the Railway Tavern to the right. It was refronted in 1845.

Former landlords of this establishment include Joseph Kirby (1806), John Baraclough (1828 and 1835), John Lowe (1841), William Beard (1874), Titus Robottom (1879), possibly 'Mrs' Robottom (1896), and Alfred Hood (1912). In 1933 the host was a twenty stone giant named Ted Hutt, the same Ted who formerly kept the Kings Arms around 1938, known as 'the boxer's pub'. Mr S. W. Badger was the landlord in around 1938. The Crown is reputed to be haunted. The landlord of the Crown, Titus Robottom, who was also an engineer, hired an electric generator from Siemens in Stafford in the year 1878 to put on a floodlit football match between Atherstone and Tamworth at the Newdegate Arms sports ground. It wasn't a great success, albeit quite a novelty, as the lights kept going out and after being plunged into darkness, several people who were tending the generator received electric shocks while fiddling with it. Nevertheless, refreshments had been provided by the Nuneaton Brewery Co., so some entertainment took place.

The Crown was renamed several times in recent years. It was known as the Fettler's Firkin, The Red Rooster, Lloyds and then finally went back to the Crown in 2006.

12. The Bell and Fleur de Lys, Bond Street
In 1806 it was licensed and owned by Daniel Wagstaff. It seems to have continued in the Wagstaff family and was recorded as late as 1863, when it was kept by a Thomas Wagstaff.

The Hollybush
The Hollybush was in Bond Street next to the Leicester Road Bridge, although this bridge was not constructed until the 1870s.

This established old pub was rebuilt in the early 1930s. The new pub was built at the back of the old one that was closed in October 1934. It ceased to be a pub in April 1986. It has now become an office building, known as Hollybush House. John Archer kept it in 1808, Joseph Harrold was the landlord in 1835, Thomas Large in 1850, Joseph Mills in 1874, Thomas Fortescue in 1876, and then Mr T. J. 'Tuddy' Lilley before he went to the Newdegate Arms. In 1912 T. G.W. Baker was the tenant and in 1933 the landlord was C. E. Wager.

The pub was associated with the angling fraternity in the town. For many years it had a function room and in later years this was later a venue for discotheques and dances. These days it is used as converted offices.

Bricklayers Arms

The Bricklayers Arms was a beerhouse in Blind Lane, an alleyway that ran from Back Street to Bond Street. The building had been demolished by the 1920s. Dick Sidwell used to be the landlord.

13. The Railway Tavern, No. 16 Bond Street

This ancient Nuneaton pub still trades today. It is believed to have opened at the time the Trent Valley Railway was completed in 1847.

The premises had been formerly occupied by a wheelwright named Dennis Marklew, a native of Burton-on-Trent, born in 1806. He had been at the premises we know now as the Railway Tavern since 1835, if not before since he married a Nuneaton girl in 1829. The pub remained in the Marklew family for many years; his daughter Sarah (1841—) was the landlady in 1871 and continued there as landlady in 1881. By 1900, Joseph Henry Pipe was the landlord and remained there until his death in 1911. Mr Pipe's oldest daughter, Annie Pipe, married John Bostock in 1903. John's family ran an old, established, Nuneaton butchery that traded from the eighteenth century until their recent closure in 2015. The Ancient Order of Buffaloes friendly society used to meet at the Railway Tavern. The landlord here in 1933 was S. Hickling.

Other Bond End and Bond Street pubs included:

The Mount Pleasant (Bond End), an 1830s beerhouse; The Horse & Groom (Bond End), another 1830s beerhouse; Prince's Feathers (Bond Street), premises occupied by Mr J. Clay in 1899; The Lamp Tavern (Bond Street), it was on the site of Mr W. Grubb's shop in 1899 and William King was the former tenant when it was a beerhouse; L & NWR Refreshment Rooms, the last house on left before entering the gates to the station yard, it was kept by Arthur and Eliza Chinn at No. 23 Bond Street.

REGENT STREET

The Dun Cow

This ancient pub stood roughly to the left of Regent Street, where it enters Bond Street. It was obliterated when the new railway was built and the former roadway was altered to accommodate the Trent Valley tracks. The old pub was tenanted in the early nineteenth

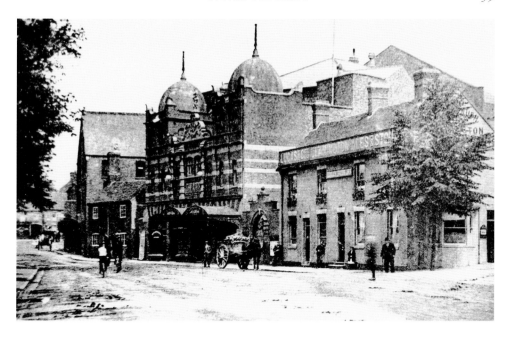

The Hollybush next to the Prince of Wales Theatre.

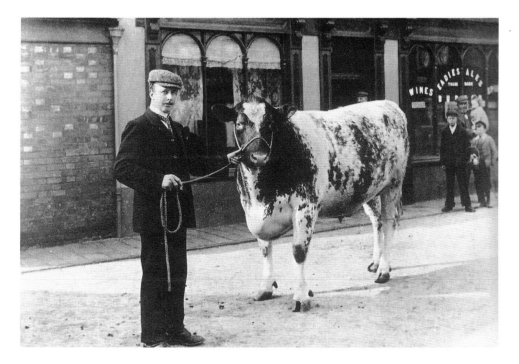

John Bostock with one of his prize bulls, which long ago was turned into magnificent steaks to grace the tables of our Edwardian ancestors. Pictured outside the Railway Tavern before the First World War.

Albert Ball (on the left) is passing the time of day with a lady acquaintance who is with a bicycle. Mr Ball was the proprietor of AB Taxis whose premises you can see on the opposite corner. Roughly where Mr Ball is standing was the edge of the ground occupied by Nuneaton's most haunted public house, the Dun Cow. This whole area was altered when the railway was built and this stretch of Regent Street (then known as Brick Kiln Lane) was changed. The grubby set of buildings were new in 1845 and were demolished in 1957 after being badly damaged in the Blitz.

century by Richard Beet. The Dun Cow once had a reputation of being Nuneaton's most haunted pub. In the nineteenth century, across the fields from Nuneaton town stood a jumble of grey stones, tumbled down walls and derelict cowsheds. This was the remains of the old manor house of Nuneaton named Horestone Grange. When the Nuneaton to Hinckley line was built (opened in 1862) it cut straight through the remains of the grange and the rubble was ploughed into the earthworks of the railway. Its three moats were partially filled in. In later years the outer moats were also filled, in one case with wagon loads of the remains of old London & North Western Railway crest-printed china that had been thrown out when the grouping of the railways took place in 1923.

Before this, the remains of the Grange, that had fallen into further dereliction year by year, stood grey and forbidding in an area remote from the town. Our ancestors considered it a place not to visit in those far-off superstitious days. Its reputation was so terrifying that few would venture near it. The ghostly figure manifested itself onto the area of town nearest to its site. The streets that we know today as Wheat Street, Oaston Road (formerly Odd-a-Ways Lane, or Horestone Lane), Regent Street and Bond End were blighted with its presence; people were scared to linger in these roadways at the dead of night.

In the seventeenth century the Stratford family (one of England's largest landowners and richest families) acquired part of the manor of Nuneaton. John Stratford bought

Horestone Grange in 1648. It became his principal seat, but it was not long before he cast his net wider for more real estate to buy in Warwickshire. He purchased the Brett's Hall and Ansley Hall estates, which he merged into one, followed by Merevale, where his descendants through a female marriage remain today – the Dugdale family.

Another property held by the Stratfords was a remnant of the old Abbey in Nuneaton, whose lands at that time extended down to the market place. A few yards to the north of the market place was another substantial mansion known later on as Nuneaton Hall. It was said to be the dower house for the family. We do not know just when it fell out of use and became unoccupied. By approximately 1800 the Hall itself had become derelict and it was demolished around that same year. Stratford Street was built around 1850 on a piece of ground called Hall Gardens, which was part of the extensive grounds of the old mansion. This may have been the old habit or the abbot's house of the abbey itself.

John Stratford moved out of Horestone Grange (probably before 1676) when it was let it to Charles Beale, who used it as a woollen cloth factory. The wool business was part of the commercial empire of John Stratford's family who were wool merchants and dealers in woollen cloth on the London market. By this time the Stratford family were very rich landowners with 26,000 acres of land in Ireland and 8,000 in England, mostly in Warwickshire. The family also owned Stratford House, just off from Oxford Street in London. They also had extensive business interests in Europe, particularly Hamburg in Germany. In the seventeenth century the Stratfords were reputed to be the second wealthiest family in England, with property and assets worth over one million pounds at the time, a staggering amount of money for the period; earnings from the production of tobacco on their Cotswold estates was itself worth £20,000 per annum. By the eighteenth century their fortunes had waned a bit. Members of the family found themselves on the wrong side of Cromwell after the Civil War and had their property confiscated, but somehow the Warwickshire Stratfords managed to stay in favour throughout this troubled period.

Charles Beale occupied Horestone until his death in 1699. Members of his family believe today that his son (also named Charles) carried on the business at the remote grange during the early eighteenth century. At this time Horestone Grange hardly gets a mention in the written records, but it is clear that it was complete and extant until around the 1740s. No occupants at that time are known but the Stratfords still owned the property, it is likely their descendants retained it as late as the 1970s because it was still then open fields.

Around the year 1740 Horestone Grange burnt down in an all-consuming fire. According to local folklore, one of the Stratfords (thought to be Edward Stratford) was fatally injured when he fell from his horse and had to be rushed back to the Grange.

In Nuneaton, the Stratfords were not well thought of and had a poor reputation in the eyes of local people. This was mainly because up until that time the residents of Nuneaton town had ancient rights of common on Horestone fields – in other words they could graze their animals there in accordance with some old statute. In 1735 the Stratfords succeeded in enclosing Horestone fields and gave as compensation a piece of ground between Weddington Lane and Higham Lane, later known as Cottager's Piece. This is why there was a pub in that area – The Graziers Arms – named after the local people who had an ancient right to graze their animals on Cottager's Piece. There

was another pub close by too known as the Gardeners Arms that took its name from those old Nuneatonians who gardened strips of vegetables on this common land. The graziers and the gardeners liked their refreshment before staggering home, under the weight of their sacks of potatoes and vegetables, to their court tenement cottages in Nuneaton town.

The locals took a dislike to the squire of Horestone Grange for his act of enclosure, presumably taking account of his reputation for drinking in the inns and taverns in Nuneaton town, they nicknamed him 'Lord Hop'.

Alfred Scrivener (1845–1886), editor of the *Nuneaton Observer* in 1878, took up the tale:

> Where the North Western station now blocks the way was formerly an open green, the Leicester highway broadening out at the entrance to the town. Nearby in Bond End, stood the Dun Cow round which yet lingers traditions of the ghostly Lord Hop, who was believed to have driven about this end of town at midnight in a phantom carriage drawn by four headless horses. The awful charioteer was supposed to have been former owner of Oaston, or as Dugdale spells it "Horestone" Grange on whom this dreadful penance was imposed for the unlawful enclosure of common lands. I know not why he should have imposed his ghostly visits on the Old Dun Cow, but some 70 years ago (1808), a pot valiant guest, mocking at the tale, wagered to sit all night in the inn alone. In the morning he was found senseless. His fright was followed by a long illness, but no persuasion could ever induce him to tell what he had seen. The Dun Cow in spite of this equivocal reputation had the advantage of possessing a large and commodious barn, and here companies of strolling players ranted on improvised boards, and unlocked the source of pity and of terror in the breasts of our venerable grandmothers.

For many years after this the ghost of Lord Hop was seen to manifest himself on anyone apt to wander abroad in the unlit winter nights around Horestone Grange. Residents were scared stiff by these hauntings. The vicar of Nuneaton was called in and asked to put this spirit to rest in an act of exorcism. The tale has it that the ghastly phantom was exorcised into a bottle. The cork was pushed in and the bottle was flung into a deep, abandoned, waterlogged, clay pit, (then on the corner of Wheat Street and Regent Street, opposite North Warwickshire House). The area at the time was hardly built on, being mostly orchards and small holdings. It was greatly altered when the railway was cut through.

One very hot summer in the early 1800s, the contents of Lord Hop's pit almost completely dried out, someone peering over the edge spotted a mud-crusted bottle and extracted it. Curious to see what it contained and not being familiar with the tale of the exorcism, they pulled out the cork. There was apparently a terrifying whooshing sound and, once again, the ghost of Lord Hop was at large in the miry lanes of the area. It made itself a particular nuisance to the regulars of the old inn, The Dun Cow, until the pub was demolished. The railway caused the site to be altered and from that time on little has been heard of Lord Hop.

QUEENS ROAD FORMERLY QUEEN STREET, GAS STREET AND WASH LANE

14. The George & Dragon, Wash Lane (later No. 26 Queens Road)

The property that was to become the George & Dragon was purchased by Joseph Scrivener (1793–1859) around 1816. Mr Scrivener was a rope maker and he laid out an extensive ropewalk at the rear of his newly purchased premises. At the rear of his front house he built ten tenement cottages that subsequently became known as Scrivener's Yard (later known as the George & Dragon Yard). When Joseph Scrivener died he was superseded as a rope maker by Isaac Hogg, who was also listed as a rick sheet maker in 1880. Later, the rope maker was the well-known Charles Phillimore. In the late 1930s these cottages were left disused and were taken over by the council after the night of the large Blitz on Nuneaton in May 1941 and utilised as a temporary mortuary. Around 131 bodies and body parts had to be brought here to be identified by their relatives and prepared for burial. A council employee, Frank Hextall, who served in the First World War and had witnessed the carnage on the battle-fields of France, had this harrowing job to do. W. B. Whitmore was the landlord at the George & Dragon from before 1912 around 1939.

Other Wash Lane pubs include:

The Dukes Head – licensed to John Mallabone in 1806, its location is not recorded; The Volunteer – an 1830 beerhouse; Cross Keys – Z. Drakeley was the victualler; Stag and Pheasant – W. Congreve was the victualler; White House – just over Wash Lane (the Cock & Bear) bridge towards Stockingford, its exact location is not known, Arthur Payne was the tenant.

The George & Dragon currently stands empty, ready for redevelopment. When the property was demolished in August 1965, a complete thatched roof made the demolition a dangerous experience. A row of ten tenement cottages were at the back known as Scrivener's Yard, later George & Dragon Yard.

The Red Lion, No. 8 Queens Road

It was kept by William Buckler in 1801, Henry Green in 1806, Hepzibah Hastelow in 1828, John Boswell in 1841, S. Thompson was the licensee in 1912, and C. T. Godderidge was the landlord in 1933. In the 1970s the Red Lion merged with the new townscape, but was demolished soon after.

15. The Cock & Bear

The license goes back to 1806 at least, perhaps earlier. The licensee at this time was John Smeaths. In 1828 it was Mary Smeaths, Sarah Moreton was there in 1835, John Mallabone was licensee in 1841. It was later tenanted by George Moreton a well-known local horse and cattle doctor. George Taylor was the licensee in 1896 and in 1907 John Hill was the tenant. John Hill was evidently a bit of a reckless character as once when a circus came to town (before the First World War) he entered a cage of lions for a £5 bet. J. Lonsdale was the tenant in 1933, C. H. Marston was landlord in around 1938. Charles Nelson was a landlord in later years, he retired aged sixty in 1988 after twenty-one years in charge.

PRINCES STREET

16. The Harcourt

This was named after an old resident in the new licensed premises, George Harcourt Taylor (one of the victualling Taylors). It had formerly been a private property known as Harcourt House that was last lived in by Henry Barrett MRCVS. It was thought to have had the license transferred from the Midland Railway Inn that was bombed and destroyed in a German air raid in May 1941.

CHURCH STREET

The Marquis of Granby (The Granby's Head)

The Marquis of Granby, later the Granby's Head, is located on the corner of Church Street and Bridge Street. The real-life Marquis of Granby was John Manners, third son of the Duke of Rutland (1721–1770). He was a popular soldier in his time, having made a heroic name for himself at the Battle of Minden as the head of his regiment, the 'Leicester Blues'. Some of his regiment, upon retirement, opened pubs in his name. He was a hero of the Seven Years War (1756–1763). The first pub named after him was at Hounslow. We can only assume that the Nuneaton pub got its name in the same way.

The pub was associated with the Trickle family for thirty-six years (1792–1828), but by 1841 it was called the Old Granby's Head and kept by Joseph Orton. In 1912 the tenant was William Thompson. Up until 1925 Henry Axon was the licensee. In 1896 the landlord was R. Townshend and in 1933 it was tenanted by L. Penn.

Kings Head

By 1896 the beerhouse keeper was Jane Knight. By 1912 it was tenanted by H. J. Dudley, who was the licensee for at least twenty years. As far as I can tell it was always

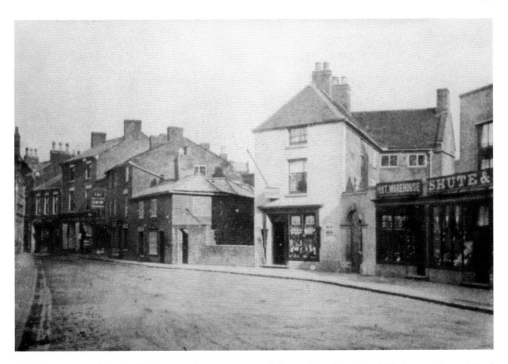

The large sign of the Red Lion can be seen centre-left, at first-floor level. This was the original pub before a new one was built about the turn of the nineteenth century.

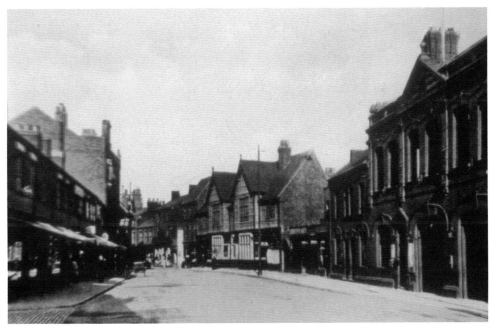

The replacement Red Lion was a fine pub and it dominated this part of Queens Road. The municipal offices and old fire station are on the right.

The original Cock & Bear, later replaced by the modern pub. This old building was reportedly blown down in a high wind in 1890.

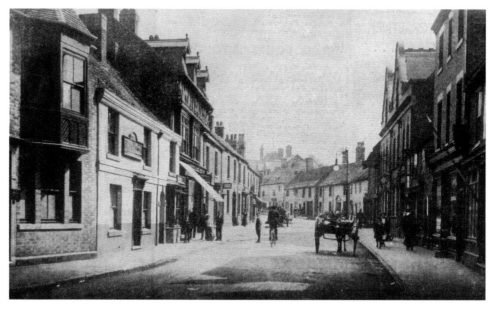

This shows the Kings Head in an old postcard. The pub can be seen on the left looking up Church Street.

a beerhouse and never a full-blown pub. Beer was served from casks of ale stacked at the back of the bar dispensed into jugs.

Queens Head (later the Pen & Wig, also Reflex)

The replacement Queens Head pub was designed by local architect Arthur Moreton (1864–1931). The Queens Head was extant in 1792 when it was kept by Elizabeth Watts. William Johnson was the licensee in 1806, Charles Randle in 1828, William Thurman in 1841, William Bond in 1863, and Eliza Pickering in 1896. In 1912 W. Pickard was the tenant and the landlord in 1933 was George H. Deane.

Double Plough

Located on the site of the Close (Alderman Melly's house). Former landlords included Mary Mitchell in 1806 and Richard Stirley (1828–1841).

Arthur Jebbett wrote in 1955:

> Just one other reference to inns. One of the name of "The Double Plough" an old chartist house existed opposite the parish church. An informant states that he has good cause to remember this particular licensed house, for on his wedding day nearly 60 years ago the parson was not quite ready to perform the ceremony, so the wedding party adjorned to "the Double Plough" for a livener." Dr. E.N.Nason who took a keen interest in local history wrote in 1936: "Just beyond' the Close' [Ald. E.F.Melly's house latterly] the last house on the right there was an inn called the "Plough" {in fact" the Double Plough"}. This was an old thatched roof, whitewashed walled building, above the door of which was a small scale model of Plough as its sign. It was here that the bell ringers from the parish church, when

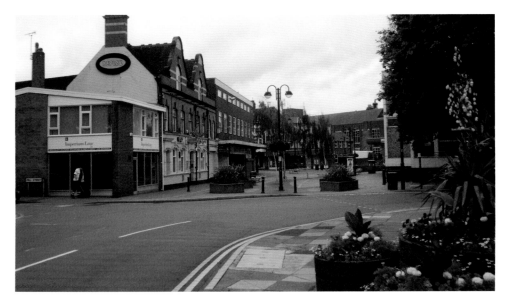

The Queens Head had been changed to The Reflex by the time this photo was taken in 2010.

they had finished their "chime" and let the bells down on Sunday morning and while the "five minute" bell was still ringing and members of the congregation were hastening to avoid being late for the 10.45 service, repaired to quench their thirst in home- brewed ale.

Rising Sun

The tenant was Charles Sands. It was just a beerhouse.

BRIDGE STREET

The Old Bull, (later the Bull Inn, the Bull Hotel, and now the George Eliot Hotel)

Two principal railway companies served Nuneaton: the London & North Western Railway and the Midland Railway. Each company gave a dispensation to a local hotel to provide accommodation for travellers using their station and 'stopping over' en route. The Bull served the London & North Western Railway station on the Trent Valley route. In addition to providing an omnibus service from the station, the railway company collected parcels from the Bull for them to distribute. Local people would take their parcels to the hotel for onward transmission. The Bull was said to be the inspiration for the Red Lion in George Eliot's *Scenes of Clerical Life*. It was originally a coaching inn and the town's post office. W. J. Dowding was the publican in 1912. Mr R. A. J. Rhodes was the hotelier in 1933.

HINCKLEY ROAD

17. The Graziers Arms, 1 Hinckley Road

In its early years The Graziers Arms was licensed by William Pickering. By 1874 it was David Ensor (1844–1923), a local farmer. By 1892 the licence had been transferred to William Henry Trinder (1854–1896) whose widow Maria Trinder (1855–1929) continued until at least 1908. By 1912, and for the following twenty years, the landlord was Arthur Walpole (1880–1939). Some time between 1932 and 1940 the licensee was Robert Hardy, who maintained the tenancy until the old pub was demolished in 1963. A replacement pub was built on the site but that lasted just over forty years, before it too was demolished. The site is now occupied by a Kentucky Fried Chicken fast-food restaurant. Before it was closed down there had been some suggestion to turn the site into a supermarket, but this did not materialise.

WEDDINGTON LANE AND WEDDINGTON ROAD

Midland Tavern

This was opposite the Graziers Arms in Weddington Lane.

Gardeners Arms

Located on Weddington Lane and owned by John Biggs (1793–1881), later the landlord at the Graziers. After it was demolished the plot was left empty for a number of years.

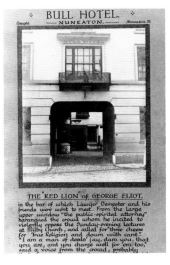

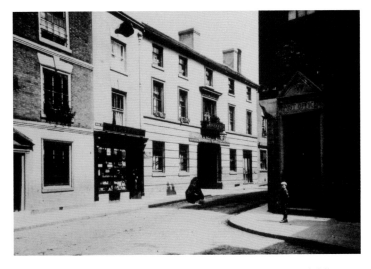

Above left: The gateway to the Bull where an old blind beggar scraped away a tune on a fiddle in return for a few coppers upon each arrival of coaches on the Warwick–Stamford run (Credit – Clare Speight).

Above right: This photograph was taken before 1909, with the Bull shown in its ancient streetscape. The former post office pulled down in 1912 is on the right (Credit – Birmingham Reference Library).

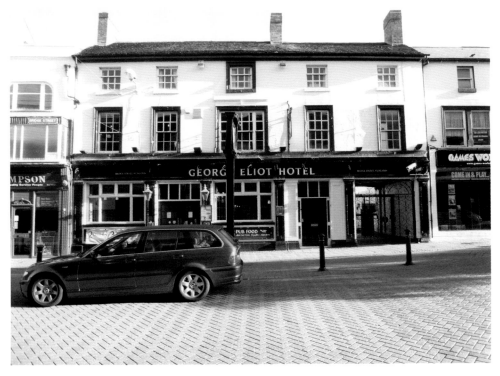

The Bull Hotel was renamed the George Eliot Hotel some years ago. This view was taken in 2010.

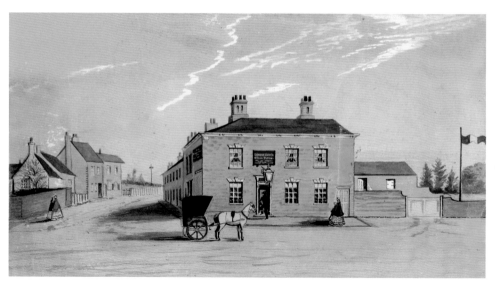

The original Graziers Arms, illustrated in this contemporary watercolour of the 1850s, not long after the Trent Valley Railway was opened.

Horse & Jockey

The site of this beerhouse is not known. There were very few buildings in Weddington Lane at the time and the name may have been applied to another beerhouse (such as the Gardener's Arms). The name was also altered when the pub had a change of landlord, one of whom was a W. Wallis.

18. The Weddington Hotel (later called the Grove and the Fox & Crane)

The pub was thoroughly modernised and traded between 1996 and 2008 as the Fox & Crane. It was purchased in 2008 by a local builder and stood derelict for six years until in July 2014 reconstruction work started to convert it into six apartments.

HIGHAM LANE

19. The Chase

The Chase was bought by Ansells in 1939 for £2,500 following the death of James Knox's widow, Florence. During the war the Prudential Assurance Company rented it as an office so that they could relocate some of their office operations away from cities that were likely to be bombed. After the war, Ansells turned the Chase into a public house and hotel. In 1972 a new twenty-eight bedroom block was built. The new restaurant seated 110 people.

PALLETT DRIVE

20. The Coniston

A modern pub that was erected to serve the St Nicolas Park estate in the early 1980s,

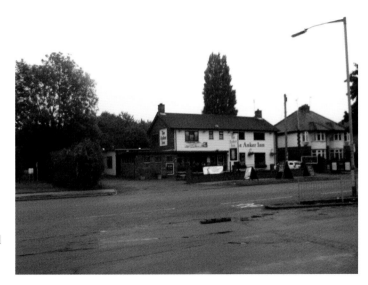

The Anker Inn – located on the Weddington Road.

it still survives today.

ST. NICOLAS PARK DRIVE

21. The Yeoman
This pub is now attached to a Travelodge and has a restaurant alongside.

THE LONG SHOOT

The Long Shoot Motel and Restaurant
This is a classic American-style roadside motel with a pub and restaurant attached. The name the Long Shoot derives from a long narrow field that the roadway we know locally as 'the Long Shoot' passed through to get to Nuneaton.

THE MARKET PLACE

The Castle Hotel & Morgan's Hotel, No. 15 Market Place
When the Castle opened its doors to admit its first customers on 1 October 1817 it was a relative newcomer to the catalogue of Market Place pubs. The original landlord was Benjamin Kelsey, who had purchased the property from a family called Wilson. In May 1823 the license was taken over by James Wagstaff (1783–1838), who had moved to Nuneaton from Market Bosworth where he was working for Earl Howe on the Gopsall Estate as a carpenter and joiner. Mr Wagstaff died on 2 July 1838 and the business was carried on by his son, also James Wagstaff. At one time Thomas Bedder ran a cart to Hinckley that started and terminated at the Castle every Tuesday. It was quite common to find pubs as the starting and finishing point for carriers. It made a lot of sense because it was a means of refreshing the carrier and his passengers after a

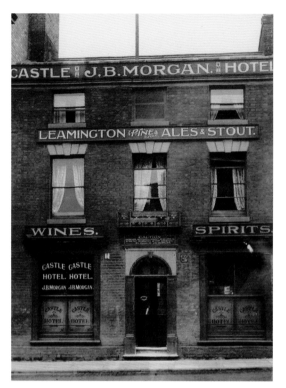

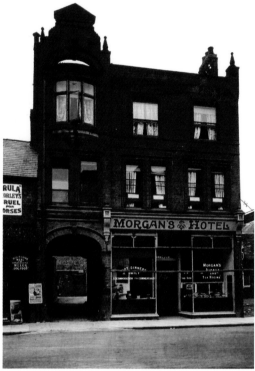

Above left: The Castle was owned by Mr John Birt Morgan. (Nita Pearson)

Above right: Mr Morgan extended his business into premises in Queens Road, which was part of Morgan's Hotel. This building was demolished some years ago. (Nita Pearson)

bumpy and long-winded journey, and provided a convenient waiting room and shelter in inclement weather.

By 1850 the licensee was Thomas Ball, followed by Thomas William Benfield in 1863, who brewed beer on the premises for a time. The local trade directories indicate that by 1868 it was owned by Frederick Lord, followed by John Argyle in 1874, then in 1880 the proprietor was Ebenezer Brown (the well-known local pub entrepreneur). Ebenezer turned the Hare & Squirrel pub (just over the road) into Nuneaton's first music hall – The Crystal Palace. While Ebenezer turned his attention to the Crystal Palace, the former licensee of the Half Moon in Abbey Street, Abraham Weston, took over the Castle. It was around this time that the Castle advertised 'The new tea and coffee rooms added to the above hotel are conducted on a low tariff adopted in modern coffee houses.' There was some attempt at the time to persuade Nuneaton townsfolk to give up booze and to conduct themselves in a less disorderly manner.

At some stage prior to 1912 James Birt Morgan took over the Castle. A miner by trade, he had travelled up to the Midlands with his brother Edmund from the Forest of Dean. Edmund became a brewer in Tamworth after a spell as the under-manager at Charity Colliery in Bedworth. James took over the Peacock in Market Place before

the Castle became available. He moved to the Castle and turned it into a thriving commercial success. Unfortunately, this would end in tragedy for James; he committed suicide on the day that his son ,Washington Grant Morgan, also died at the age of twenty-two. James was fifty-nine and distraught by the loss of his son.

In 1933, J. C. Morgan was the landlord. A later victualler was Harry Porter (in 1940). The Castle was demolished around 1968.

The Market House Inn

When the Market House property (a forerunner of Nuneaton town hall) was built in 1819, the former pub on this site, the Britannia, was demolished and its license taken over by the Market House Inn, 'The Market House Inn is let to Wm. Ratliff, of the Brewery, Coventry at £70 per year in June 1862'. In 1845 the Market House had a home-brew brewery.

The brewer, William Ratliff wrote subsequently:

> Dear Sir,
> It is not a customary thing with me to request any alteration in a bargain once made, but these fearfully bad times render it absolutely necessary that I should obtain some reduction of rent off the Market House Inn after Xmas. The custom of the house has naturally lessened by the present extraordinary depression of trade, and the loss maintained by the non-letting of stalls is also very great, from the same cause. I must ask as a favour that the proprietor of the property will reduce the present rent to £60 per annum from December 21' until the revival of trade enables my tenant once again to return to the rent. I think this request is most reasonable and I trust will be acceded to.
> Yours faithfully, William Ratliff

The trustees wrote back stating that they could not reduce the rent, but owing to the depression in trade some allowance would be made. They eventually had the 'tea room' repaired and repainted at their own cost in lieu of an allowance of rent. In 1863 the

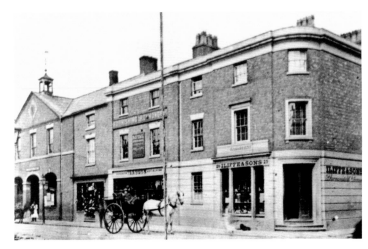

The Market House Inn was through the archway on the left, which was the original Nuneaton town hall. The old Plough pub occupied Iliffe's 'new' premises on the corner.

tenant was Joseph Batchelor. The pub and the Market House was demolished in 1900 and the site was sold for construction of the Clock Inn.

22. The Hare and Squirrel (formerly the Old Crown Inn, after being modernised it was renamed the Crystal Palace)

In around 1544 there was a reference in the Constable survey to 'the Crowne Inn' and it stated that the leaseholder was Richard Ratcliff. This may have been referring to this pub as it changed its name from the Crown to the Hare & Squirrel in the late 1700s.

The Uxbridge survey says that 'Mr John Burton for an house and backside, formerly Thomas Williams, Inn holder late Smart and now in the possession of Job Beamish (Called the Old Crown Inn)'. Job Beamish provides the clue because the family of Beamish were associated with the Crystal Palace (or The Hare & Squirrel as it was then known) for many years. Job Beamish (1765–1823) was listed in the trade directory for 1792, by 1801 his son (John) had taken over the license. Mary Beamish had succeeded John by 1828 and was still there in 1835. The Beamish family had a very long association with Market Place pubs, they also kept the Peacock for upwards of forty years after 1841 and they were painters and decorators at No. 6 Church Street for a hundred years thereafter.

I have a note that James Ball (who married Sarah Beamish in 1837) may have taken over the Hare & Squirrel shortly after their marriage, so the pub continued in the family.

In the 1860s the Hare & Squirrel was purchased by one of Nuneaton's most interesting characters – Ebenezer Brown. Generations of the Brown family lived in Attleborough for over one hundred years in a cottage in Garrett Street. Ebenezer's father, Thomas Brown, was born in that cottage in 1799 and died on 29 May 1871, his son Ebenezer was born on 4 July 1828. He went on to become one of the richest men in Attleborough. This was the start of the Crystal Palace's most interesting period.

The first trade directory entry for 'Eb. Brown' is from 1863 when it was still called the Hare & Squirrel. Ebenezer is said to have purchased the pub for the sum of £290. Mr Brown started in the entertainment business when he taught himself to play a violin at the age of seventeen and formed a band known as Brown & Furmans. He later purchased a coal round and later made an investment in a newspaper. He was thrifty and accumulated capital sufficient enough to buy his first pub around the year 1860. He purchased the Castle and the Crystal Palace and went on to accumulate a local public house estate of twelve pubs, despite being teetotal himself. In 1879 the Leamington Brewery Co purchased his estate for a sum of £23,000 (approximately £2 million today). He then retired from active business, but continued living at Attleborough and had a holiday home built in North Wales.

The change of name for the Crystal Palace must have taken place around 1871, when Ebenezer Brown turned it into Nuneaton's first music hall.

The pub was later tenanted by George Harcourt Taylor, who was also listed as a wine and spirit merchant, tent hirer, coal merchant and, for good measure, had a pony and trap for hire too!

These were the great days of the Crystal Palace, with its many theatrical, novelty

The bottom of Queens Road (or Queen Street, as it was known) looking into the Market Place with the Red Lion pub on the right and the Crystal Palace to the left of the entrance into the Market Place. Mr W. Bennett the hairdresser stands to the right. The year is 1909 and the Crystal Palace will soon be demolished for road widening and the photograph may have been taken to illustrate the scene before demolition took place. The bay window of the Red Lion is on the right. A large selection of Victorian posters are emblazoned on the wall opposite. The roof light illuminates rooms which are part of the Crystal.

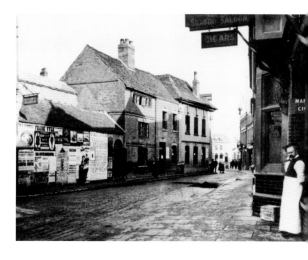

This photo was taken around the same time as the previous one. In fact, probably within minutes of it since the little truck in the foreground that looks like a fruit box on wheels is in both pictures. The very narrow character of the entranceway to Queens Road can be seen. You have three pubs in this view. The Castle is to the left of the little girl with her grubby pinny. The gable ends of the Red Lion and the Crystal Palace are in the centre.

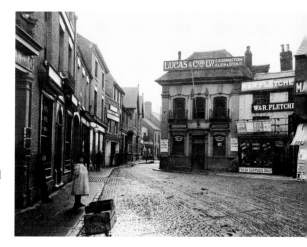

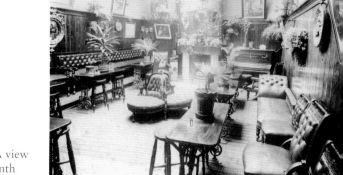

The finest smoke room in Nuneaton. A view inside the Crystal Palace in the nineteenth century.

BRANDY PURE AND UNADULTERATED,

AT THE

CRYSTAL PALACE, NUNEATON.

—o—

E. BROWN

RESPECTFULLY informs his Friends and the Public generally that he continues to supply Martell's and Hennessey's PROOF BRANDIES, at the Lowest Possible Profit. Also, PURE JAMAICA RUM, SCOTCH and IRISH WHISKIES, and Nicholson's LONDON GIN,

With a Challenge to the World for Quality and Price.

—o—

FOREIGN PORT AND SHERRY WINES,. from 1s. 2d. per Bottle. VERY FINE DITTO, 1s. 6d.
FINE OLD PORT, 3s. per Bottle.

—o—

AGENT FOR BURTON ALES.

Evidence of the change of name to the Crystal Palace.

and artistic soirees available to customers. Touring singing groups, small bands, bawdy comedians, groups of traveling players and speciality acts, jugglers, and brassy women artistes all trod the boards at the Crystal. Ebenezer Brown was the inspiration and his entertainment interests also led him into being one of the founders of the company which built the Prince of Wales Theatre, better known to recent generations as the Hippodrome.

Frederick Wrighton was the landlord at the Crystal in 1884, when he died in 1895 his widow Annie Wrighton retained the license. Mrs Wrighton had ambitious plans for the expansion of her entertainment business: she took over a house with spacious grounds attached to lay them out as the Palace Gardens in what is now Queens Road. She then bought the Queens Road property in September 1897. It was intended to be a place where promenade concerts could be held on warm summer evenings and fairy lights in the trees were to create a magical effect. Unfortunately, she could not get a license to serve alcoholic refreshment so the venture failed, it was let instead for £200 per year to a local working men's club. This was a very short-lived affair as they were only in occupation for approximately three months. The Palace Gardens remained, however, and later a cinema was erected on the spot for The Palace that many of us remember from our youth.

In October 1899, the Crystal Palace was sold for £800 to Henry Benjamin Jennings, formerly of the Prince of Wales in Moseley, Birmingham. At Christmas that year, Mr Jennings announced 'There will be special attractions in the finest smoke room in the town, for Christmas. The abilities of Mr R. A. Hughes and Mr George Wynne in the musical line are a sufficient guarantee in this direction!'.

The new century brought an increase in the local population and so more traffic was trying to squeeze through the narrow gap that the Crystal Palace formed at the entrance to and from Market Place. As a result, the fledgling borough council embarked on their first scheme to improve traffic flows through the town centre. The Crystal Palace was

earmarked for demolition to ease the congestion. The last landlord there was George Luckman, who called time at midday on Tuesday 5 October 5 1909. Simultaneously, Mrs Luckman opened the doors on the brand new Crystal Palace, built in Gadsby Street, Attleborough, that had been built at a cost of £2,000. The cost for the council to pull down the old pub and make alterations at the Crystal Palace corner was £1,175.

The White Swan

The landlord of the White Swan (1806) was John Buswell, according to the victualler's returns for that year. The last landlords, George and Winnie Handley, had been in charge since they took it over in 1953. The previous landlady was a formidable woman named Harriett Platt. She was the widow of Peter Platt, who died in a flu epidemic in January 1922. Peter (born in 1883) had been a top-notch footballer who played for Blackburn Rovers, Luton Town, and lastly with Nuneaton Town. When he married Harriett she was a widow at the time; her late husband, Joseph Bradbury, had been the landlord of the White Swan. Peter had obtained the license by 1912. It was an Ansells owned house. The White Swan was closed on Sunday 30 December 1962. The premises were purchased by Lester's, the chemist.

The Peacock

According to the Nuneaton diarist, this public house was put up for auction in March 1828. The highest bid was £870. Former tenants include Thomas Thurman (1806),

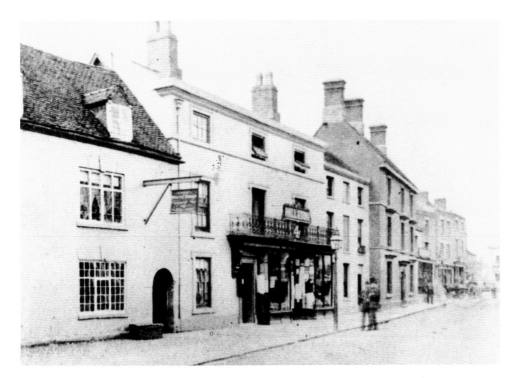

The earliest view we have of the White Swan, as it appeared in the late nineteenth century.

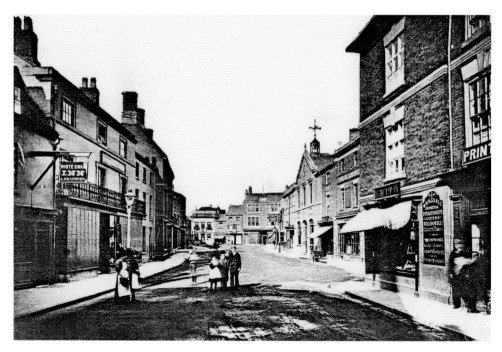

The White Swan (on the left) had been refronted by the time this view was taken. Look how neat and orderly the market place used to be in the 1890s. The Crystal Palace frontage can be seen above to the left. (Credit –Clare Speight)

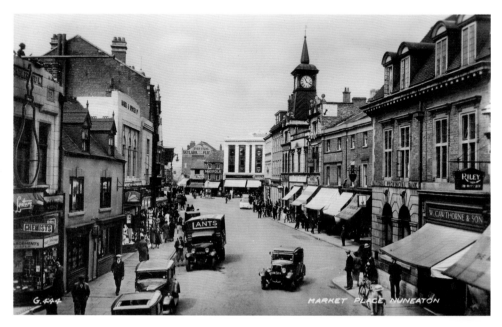

A later view of the White Swan (on the left) in a lively view of the Market Place from the 1930s.

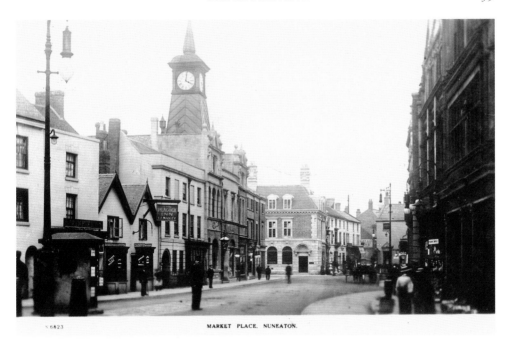

The Peacock Inn (on the left) with its distinctive low old-fashioned frontage, around 1910.

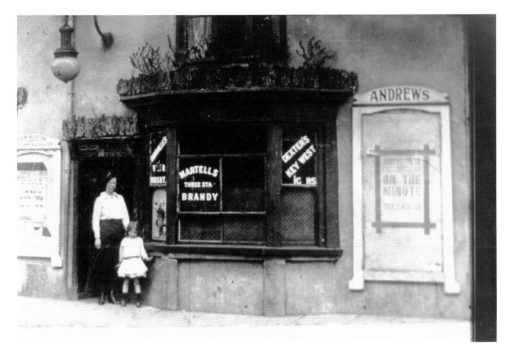

The landlady at The Peacock before the First World War, possibly Mrs Munton.

Edward Thurman (1828), and Edward Beamish (1841–1863) whose family were long-established victuallers, formerly at the Hare & Squirrel. In 1912 Henry Munton was the licensee. The building itself was an ancient property that likely dated to the seventeenth century and was replaced around the year 1930 by more modern premises. In 1933 the landlord was J. Davies. It was an Ind Coope House.

The Old Ram

'*Le Ramme*' was listed in the great survey of Nuneaton, carried out by Sir Marmaduke Constable when he took an inventory of all the property he had acquired in the manor during the years 1543 and 1544. At that time, the former owner was John Brooke of London and it was licensed to Richard Jely. The first nineteenth century landlord I can find in the 1806 victuallers returns is Robert Jelly (1780–1840), a native of Leicester, but most likely not related to Richard Jely. Later landlords included James Palmer (1828) and Daniel Green, who bought the freehold in 1835 from Mary Hutchins for £464. At this time the Old Ram had gained a bit of notoriety for cock-fighting. John Sands sold the license in 1847. Thomas Bills was the licensee in 1850, Henry Johnson was landlord in 1863, followed by Charles Morris in the 1860s and 1870s. It is possible that Charles Morris was the last landlord because this extremely old pub was demolished in the early 1870s and replaced by a shop. It stood to the left-hand side of the White Hart. Market Place was quite remarkable for having three pubs standing next door to each other at one time: The Ram, the White Hart and the Castle.

The White Hart

The pub name, the White Hart, was very popular in this part of the Forest of Arden due to its deer hunting traditions. In 1806 landlord here was Thomas Cox, followed later by William Wagstaff (1828), Taylor and Estlin (1841), David Bosworth (1862 and later). It was probably demolished in the 1880s.

The Old Cock

The Old Cock was demolished in 1818 to build the Market House and conveyed to the trustees of that establishment for a sum of £800 raised by public subscription.

The Plough

Owned by Joseph Walton (1806), Sarah Robinson (1828), Samuel Warren (1841). See the notes on the Plough & Ball on Abbey Green, it has more information on this pub that was demolished in 1845.

The Bear

All we know about this hostelry was that it was recorded in the Nuneaton survey of 1543/44 (Constable Survey). The occupier was William Smyth (the tenant of Richard Herynge of Coventry).

The Clock Inn and the Market House Inn

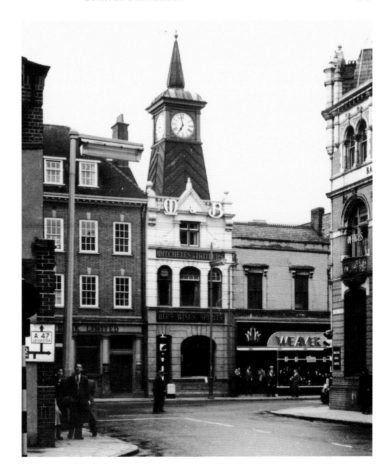

The Clock Inn.

The Clock Inn, under the town clock in the market place, replaced both the Market House Inn and the Market House property that stood here until 1900. The clock on top, which has become an iconic part of Nuneaton town centre, was started at 5.05 a.m. on Wednesday 15 May 1901. The Clock Inn stretched right through to Newdegate Street, also be accessible through the archway. Mrs M. J. Humpage was the tenant in 1933.

The Grapes
Mr Barlow's liquor shop was formerly two licensed houses: the Grapes and the Board Inn, back-to-back with a whispering gallery. The license to the former public house, the Grapes, was abandoned at an unknown date in the nineteenth century.

The Board
The Board was kept in 1806 by Thomas Thompson and by Mary Taylor in 1841. In 1908, the pub was sold to Mr J. Ravenscroft of Stockport for £10,000. He traded as Ravenscroft & Sturgess in 1912. It was tenanted by W. Stafford in 1933. The Board was demolished in 1956 and the license transferred to a new pub in Vernon's

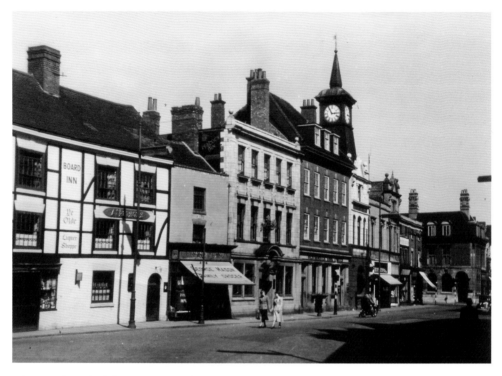

The Board on the left in 1951. (Credit – Reg. Bull Collection)

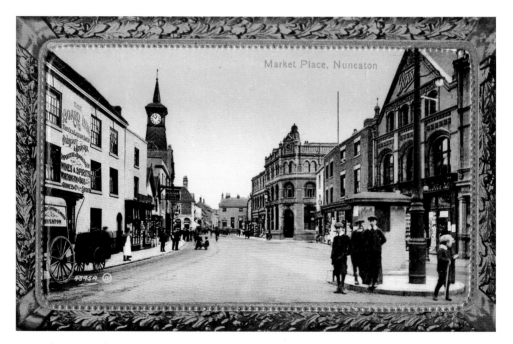

An earlier view of the Board from ground level, seen to the left, with the Peacock beyond. This photo dates to 1909–1912.

Lane, which was taken down to make way for new flats in 2003. The Board was previously a lovely old fashioned pub that may have survived in more enlightened times.

VICARAGE STREET AND WHEAT LANE

23. The Black Horse, No. 52 Wheat Street
This was an Ind Coope and Allsop's house, located on the corner of Vicarage Street and Wheat Street. It was well known for boxing at one time. The pub was demolished during the summer of 1959.

W. Varden was the tenant in 1912, John Grant was tenant in 1933, and Mrs A. Grant was the landlord in 1938–39. Its license was transferred to the Pheasant Inn on the Camp Hill estate, which opened on 4 December 1958.

24. The Heart in Hand
Vicarage Street
The Heart in Hand was built in 1850. It was directly opposite the Black Horse in Wheat Street. Both pubs were demolished for road widening. It was frequented by railway footplate crews, both before going onto duty and also coming off. It seems there were very lax drinking and driving attitudes by footplate staff on the railway during the old steam days.

T. Harris was the landlord in 1926, James Paice in 1932–23, H. Mellor was the landlord in 1938–39. When it closed and its license was transferred to the newly built Donnithorne Arms in Donnithorne Avenue, the last landlord Mr M. Blewett said that the Heart in Hand was 'Noted for its friendly atmosphere and old fashioned interior. It is more like a village pub and for one I shall regret leaving'. Now the Donnithorne Arms, its replacement, has also gone.

Jolly Fishermen, Wheat Street
John Payne was the victualler. It was a beerhouse and did not last very long.

COVENTRY STREET

25. The Nags Head
The original Nags Head was located in Coventry Street. Its early tenants were John Williamson (1806) and Thomas Taylor (1827–1841). Mr Taylor bought the pub for £800 in 1827. For many years it was associated with carters who took silk ribbons that had been made in Nuneaton to sale at the London market via Coventry. The old Nags Head was also noted for its association with cock-lighting in the first half of the nineteenth century. In 1912, A. Hall was the tenant. The later pub, in Queens Road, was built in 1929 by George Hodges & Sons, builders from Burton-on-Trent. It was a Bass Ratcliffe & Gretton house and reopened on the new site on 8 March 1929. The former premises in Coventry Street were pulled down for road widening. It was located within the tied estate of the brewery Salt & Co., of Burton-on-Trent. In 1933 the publican was G. O. Mallaban.

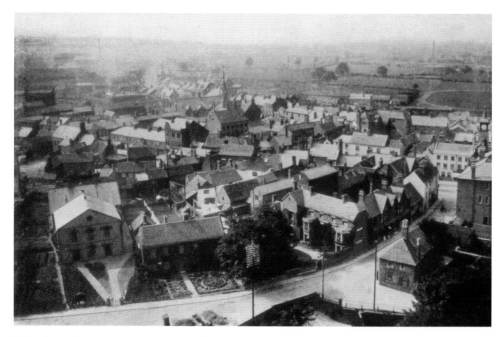

This view of Nuneaton town centre, taken in 1900, was photographed from the chimney of the Nuneaton Corporation electricity works. The 1895 rebuilt Nags Head can be seen to the bottom right corner of the picture, with three gables facing Coventry Street. The house alongside was Bridge House, pulled down in the early 1920s. (Credit – Alan Cook Collection)

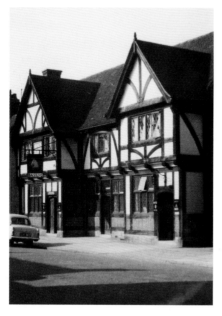

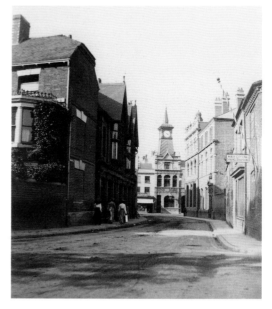

Above left: The replacement Nags Head in Queens Road. (Credit – W. H. Hope Collection, courtesy of Colin Yorke)

Above right: The original Nags Head, located in Coventry Street. (Credit – Reg Bull)

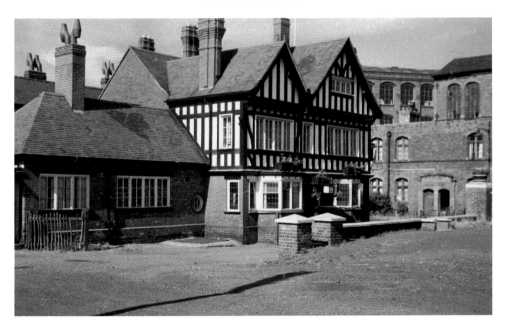

The New Inn was later called the Rugger Tavern in the 1950s. When 'Wash' Harris took it over in 1952 it was still known as the New Inn, and to generations of old Attleboroughians it was always referred to as the New Inn. In the background are the Albion Buildings and further back rises the bulk of Lister's Mill. (Credit – W. H. Hope, courtesy Colin Yorke)

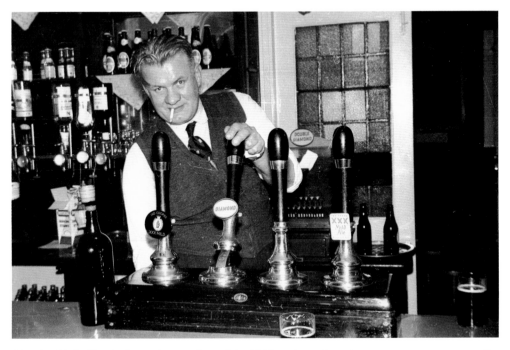

Here is 'Wash' Harris, he took over the pub in 1952 and was host for twenty-seven years, until 1979. Note that there are two kinds of mild ale both XXX. Mild was commonplace back then, but is rarely seen today. (Credit –W. H. Hope, Courtesy Colin Yorke)

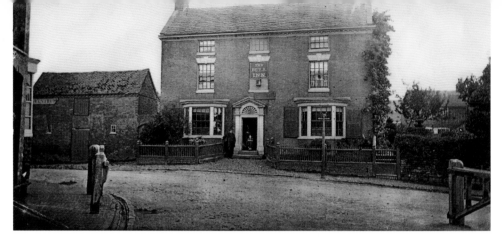

The Bull Inn, Attleborough, in the nineteenth century.

Above: Scouts rounding the corner by the Bull in the '30s. It was then a Lucas Brewery house, later to be an Ansells house.

Below: The Bull shortly after the new Attleborough bypass was opened that turned Bull Street into a cul-de-sac. The bypass was opened on 3 March 1989. (Credit – Heartland Evening News)

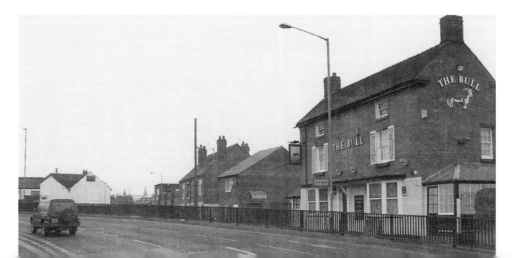

The Bull inn (1994), from Bull Street. The bypass on the right has been completed and altered the aspect of this part of the village as Bull Street became a cu-de-sac.

Attleborough

CHURCH STREET

26. The New Inn (later the Rugger Tavern)

This might be the same public house that was listed within William Dipple's occupation in a 1792 trade directory for the Nuneaton area. The New Inn moved premises to a new site on Attleborough Road, opposite to the Albion Buildings (please refer to the entry the Rugger Tavern). By 1912 it was tenanted by T. W. Harris. In 1952 the name changed to the Rugger Tavern when the field at the back became the Nuneaton Rugby Football Ground and the new landlord, 'Wash' Harris, made the pub the Rugby Club's headquarters.

The William IV

This was an 1830 beerhouse. Its location is unknown.

The Plough

This was also an 1830 beerhouse; its location is likewise unknown.

BULL STREET

The Bull Inn

This ancient pub in Attleborough, known as the Bull Inn, is believed to have been immortalised as 'the Rainbow' in George Eliot's *Silas Marner*. The building we see today dates back to the eighteenth century. The Bull Inn was believed to have had the stone outside its front door up until the nineteenth century. This is the anonymous lump of rock, set in the grass verge, along Lutterworth Road called the 'white stone'. This stone was originally part of a preaching cross that had stood there since monastic times, but was taken down around the time that the turnpike was added to the road. In 1912 the licensee was John Dickens and he was still there in 1933.

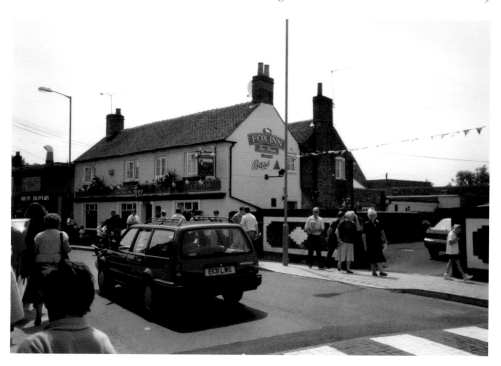

The Fox Inn (1994). A street party was taking place that day to celebrate Attleborough village centre becoming pedestrianised.

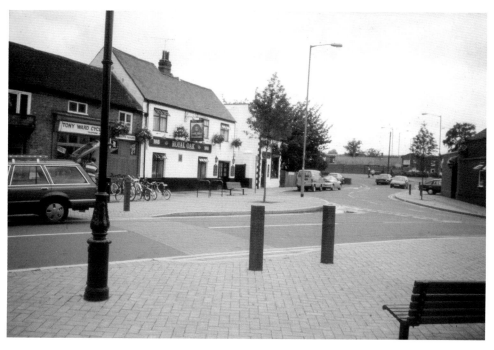

The Royal Oak has been altered and you can see the new doorway (built in the 1950s) in this 1994 view.

THE SQUARE

The Fox

The Fox is said to predate 1819; it was originally opened as a beerhouse and was attached to a grocery business. Alfred and George Weston were the tenants before 1900, Charles Moore was the licensee in 1912, H. Hollick in 1933, and W. Jack Hardy was the landlord for many years. When Alan and Josie Frisby took the pub over in 1991 they spent £200,000 refurbishing it. The new look was very tastefully done as it carefully retained the atmosphere of a village pub. In 1997 they sold the building to the Mansfield Brewery and moved to the Attleborough Arms, which they have also refurbished at enormous cost. Originally, the Attleborough Arms was destined to replace the Fox, but this did not happen; both are still trading today. The Fox is very much a typical village pub.

GARRETT STREET

27. The Royal Oak

For many years the Royal Oak was synonymous with the well-known local character Ben Mayo, a former Coventry Watchmaker. He kept it for many years, right up until the 1930s. He had been there since at least as early as 1912.

GADSBY STREET, CORNER OF WILLIAM STREET

The Crystal Palace

The Crystal Palace was opened in 1909 to replace the Crystal Palace in the market place, (please refer to the earlier entry on the Crystal Palace). The landlord was Mr T. Luckman1912, and then in 1921 it was Mr L. Carter, who advertised its proximity

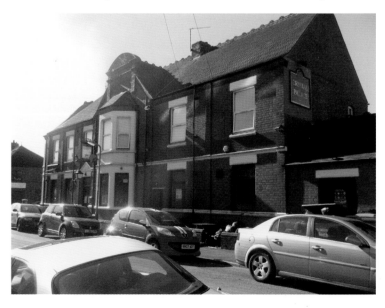

The 'new' Crystal Palace in Gadsby Street, Attleborough (2015).

to Attleborough Airfield. Presumably, since the pilots approached this airfield at the mid-point of their journey from London to Birmingham, they could consume a few pints while they broke their journey to refuel, before taking off again. The landlord in 1933 was L. P. Cross.

The Blue Bell Inn

This beerhouse formerly stood where Park Street enters Attleborough Road. To confuse matters, it was also known as 'the Seven Stars'. We have no idea when this change occurred, why, or if there was any connection with the Seven Stars in Nuneaton.

The Prince of Wales

A precise location is not known for this beerhouse. However, we do know that it stood somewhere on Attleborough Square, close to the Royal Oak.

The Steam Mill Inn

This once stood on the site of the elastic web works on Attleborough Green. It was quite an extensive beerhouse: with a parlour, tap room, club room and skittle alley. It was offered for sale in 1871 and may also have ceased to function as a pub at the same time. The operator of the Steam Mill Inn was John Miller. The Mill was knocked down to build the elastic web works on Attleborough Green.

CHURCH STREET (LATER ATTLEBOROUGH ROAD)

The Hit and Miss

It has not been possible to work out exactly where this beerhouse was located.

ALBION STREET

The Waggoners

This was situated in a stretch of Attleborough Road where the Albion buildings are based. Whether or not the pub predated Listers Mill and the Albion buildings, is not known.

LUTTERWORTH ROAD

The Miners Arms

The site for this pub is not known, but it was possibly located on Lutterworth Road and adjacent to the Attleborough stone quarry. The quarry was very extensive in its day and would have afforded work for a large number of men. It would have been convenient for business to have a beerhouse there, suitably positioned to refresh the thirsty stone miners when they had finished their shift.

The Three Crowns

The Three Crowns was said to be an old fashioned thatched tavern; it was already considered very old when Attleborough-born independent preacher, William Gadsby

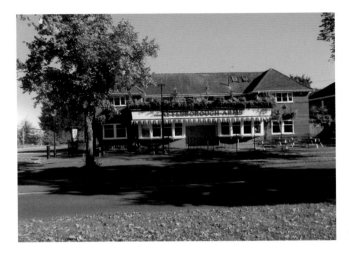

The Attleborough Arms.

The Crows Nest in September 2015. A thriving pub serving a good selection of ales.

The Acorn, September 2015.

(1773–1844), drank there in the nineteenth century. This pub would have been found along Attleborough road somewhere, opposite the Albion Buildings. It was owned in the early part of the nineteenth century by George Greenway, a local lawyer.

HIGHFIELD ROAD

28. The Attleborough Arms

This is a modern pub along Highfield Road, Attleborough. It has recently been modernised in a very high quality manner. It serves food and gets packed at the weekend. When it originally opened it was destined to replace the Fox on Attleborough Green, but happily for us, both pubs are still with us – long may they remain so.

EASTBOROUGH WAY

The Crow's Nest

This modern estate pub seems to hold its own in a challenging pub environment. It is currently thriving and serves a good selection of ales.

29. The Acorn

This was the first pub in Warwickshire that was erected with a thatched roof in 300 years. It is a modern equipped estate pub that serves bar meals. It is part of the Marston Brewery estate, but was the brainchild of John Wilmot, owner of the Quintessential English Pub Company. John built several of these traditional looking, but modern, pubs in the Midlands.

HALL END

The Woodman

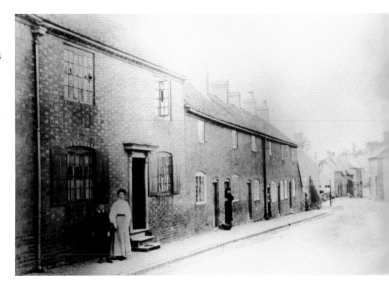

The Woodman beerhouse on the left was the home of the Hackett family for many years and was appropriately called the Woodman – the family had been woodworkers in the village for several generations. They made wooden rakes and ploughing devices used in farming, they were wood turners, made furniture and turned an extra 'bob' by selling their neighbours a few pints in their front room. The lady in the photo is Moreton Ensor's mother, here with Moreton's elder brother. (Credit – Moreton J. Ensor)

Above left: Joshua Hackett (1828-1891), proprietor of the Woodman. (Credit – Moreton J. Ensor)

Above right: The Chetwynd.

The White Stone, formerly the Hayrick.

This 1830 beerhouse was kept by Joshua Hackett (1789–1872) and his family. The beerhouse side of the family business was only carried out in the nineteenth century. Moreton Ensor told me that his grandfather's house (formerly the Woodman) had a gap under the front door that had been worn down by the thousands of boots tramping through the parlour to drink ale. This made the front room very draughty. All of the old furniture here (including an ancient long case-clock) was left to one of Jack Hackett's nephews when he died in the 1930s when it was then shipped to his home in Arles, France. It was all destroyed in a tragic fire, which destroyed the house within the last ten years or so.

The Ensor family moved to Brockton, Massachusetts, to work for the Hub Gore Co, who were elastic web weavers like the one on Attleborough Green. Moreton's grandfather on the Ensor side, James Ensor, who was also a resident of Hall End, worked at Rufus Jones elastic web works on Attleborough Green for over fifty years.

30. The Chetwynd
A modern estate pub, currently with a take-away business attached.

The Hayrick (renamed the Whitestone)
Another modern estate pub, it has a high quality restaurant attached.

CHILVERS COTON, COVENTRY ROAD

The Wharfe Inn
The Wharfe was built as a canal pub, with warehouses for boat traffic, around 1808. It was originally owned by the Arbury Estate and was later taken over by Salt's Brewery of Burton-on-Trent, ultimately being absorbed into the Bass empire. By 1896 it was tenanted by W. Wall and in 1933 the publican was Storer Winfield. There was some discussion about the pub being pulled down to make way for a new £750,000 replacement. Wiser heads prevailed as the pub was demolished in 1988 and a small estate of houses built on the site. The construction of pub's front was unusual since it was faced with rough, hard stone, probably from the Griff quarries, rather than being built out of brick.

HEATH END ROAD

The Horse Shoes, No. 2 Heath End Road
This very old victualling house was part of old Chilvers Coton and dates back to the eighteenth century. In 1896 it was licensed to J. Garrett, in 1912 W. Bray was the tenant, E. Farndon was the victualler in 1933, S. Cooper was the landlord in 1938–39. It is a good local example of a 'real ale' pub.

COVENTRY ROAD

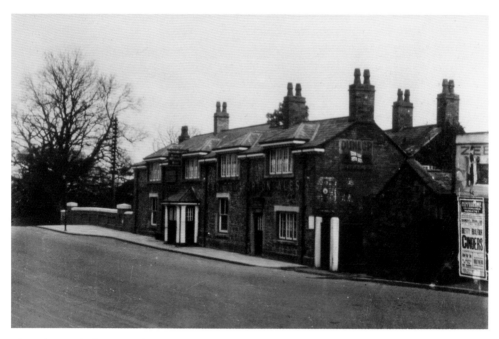

This photo of The Wharfe Inn was taken after the reconstruction and it illustrates the new bridge. The building on the far right of the pub had been used in former times as a lodging house for boatmen where they could stay 'on land' overnight after consuming large quantities of ale in the pub alongside. Straw palliases were provided for their comfort.

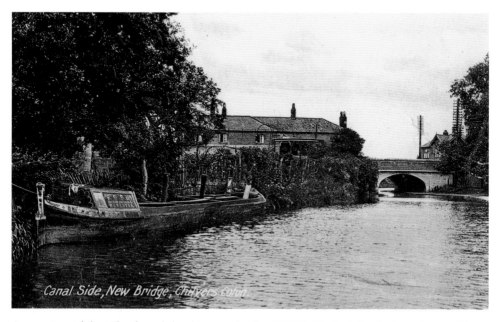

A rear view of the Wharfe and the then new bridge (1925). To the left of where the canal boat is moored was a warehouse where canal boats could discharge or store valuable cargo to avoid pilferage.

The Horse Shoes today is a modern, but traditional, real ale pub. It is thriving and has found a niche in the market for great beers available locally. (Credit – Fred Phillips).

In this view the narrowness of the gable end provides evidence of its cottage ancestry. (Credit – Fred Phillips)

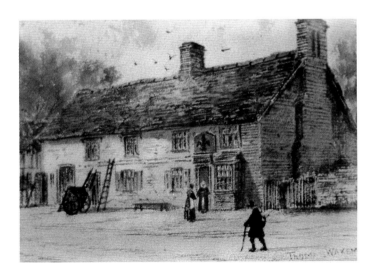

The original Fleur de Lys from an original water colour painting by Thomas Wakeman. (Credit – Fred Phillips).

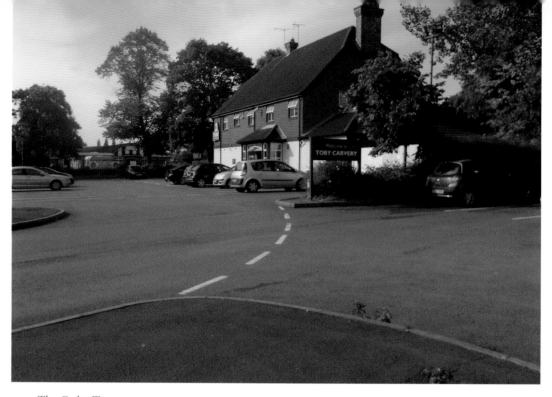

The Cedar Tree
Above: Where the Nuneaton Boys Club stands today, opposite in this view, was once a mansion house named Caldwell or Coton Hall which was demolished in around 1949.

Below: The Rose Inn survives today (September 2015).

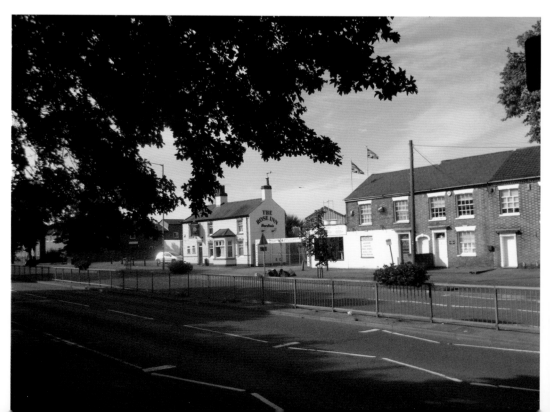

The Fleur de Lys

A very old fashioned pub stood on this site until it was rebuilt early in the twentieth century. The publican in 1806 was Daniel Wadcock, C. Broadaway was the tenant in 1896, and in 1912 the pub was let to George Dickens. After it was rebuilt, the landlord in 1933 was George W. Loose.

AVENUE ROAD

31. The Cedar Tree

The Cedar Tree is a modern pub, erected in around 1998. It has a popular restaurant and was built on former tennis courts in the Pingle Fields at a time when the ground was all an open sports field.

COTON ROAD

32. The Rose Inn

This inn survives today. Originally a beerhouse, it probably even predates Josiah Allen, the owner between 1863 and 1871. William Llewellyn was the landlord in 1896 and Arthur Jeffcoat was there in 1912. Incidentally, it was this Arthur who gave his name to the local roadway – Arthur Street. The Rose has survived the local carnage in the pub industry. It is said to be haunted by a little girl in the ladies toilets. In the period

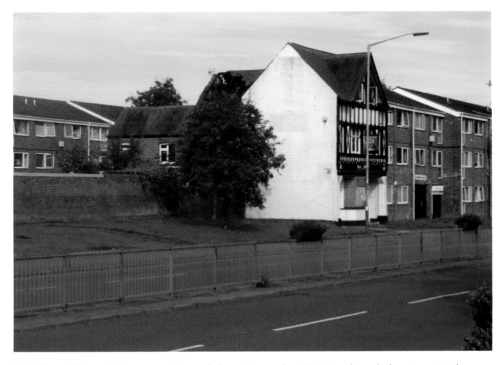

The King William IV is currently boarded up (September 2015) and partly burnt out at the rear, as you can see from the roof at the back. I expect the pub will be pulled down.

1933–1938/39, J. Bates was the publican. Tony Bates was the publican recently. The Rose's claim to fame, is that the real ale fan organisation known as CAMRA (The Campaign for Real Ale), met there for its first meeting in 1972.

The Sheepsfoot Inn

This pub was mentioned in the Nuneaton diary. It was located about half of a mile out of Nuneaton, along Coton Road. In bygone days this road had a kink, it was straightened out in the nineteenth century. This feature was known as 'Sheepsfoot End'. There is little other known information about this former beerhouse.

33. The King William IV, No. 70 Coton Road

This was one of the 'new' beerhouses that opened in 1830. The landlord was F. Bell in 1896. It was rebuilt in 1903 to the premises that can be seen today. Mr E. Dalton was the tenant in 1912. From around 1921 until 1928 the pub was run by George Clarke, who took over from his wife's family (the Brooks'). A particularly good account of life at the pub during those years can be found in a book published in 2011 titled *The Old Rebel: A Life in Nuneaton 1885–1960* and written by George Leonard Clarke. In 1933, W. E. Swann was the tenant. The pub closed in 2005, but after being stood boarded up for two years it was refurbished at a cost of £40,000 by Nigel and Della Griffiths, who reopened the pub for business in October 2007. However, since then the pub has closed and been badly burnt in a fire.

VIRGINS END

The Virgins Inn

This public house once stood on the corner of College Street at Hill Top. It is said that there was a shrine to the Virgin Mary on the corner of Coventry Road and College Street. However, at the time that the shrine would have stood on this spot, it was not called College Street; the roadway here was still called Virgins End until about the middle of the nineteenth century. That is how the pub got its name. It was located at this ancient spot, reportedly the meeting place of the Roman Catholic faith before they had their own church in Chilvers Coton.

DUGDALE STREET

34. Dugdale Arms, No. 80 Dugdale Street (later No. 34 Dugdale Street)

Originally a beerhouse, this pub may have started life as a row of weaver's cottages. In 1871 the publican was James Laughton, and the Laughton family still ran it twenty years later. By 1901 Thomas May was the landlord, by 1912 Willoughby Marston Nixon was the tenant and he was still there until 1940 when James Hope took over the license. The Hope family kept it until 1964 when the premises were demolished and a new pub was built on this site later called the Merevale Arms.

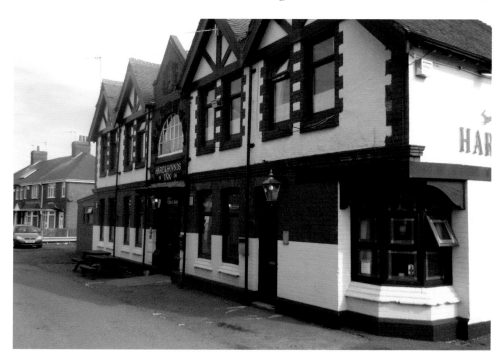

The Hare & Hounds displays its heritage. This pub replaced an earlier one in 1904 (photographed in September 2015).

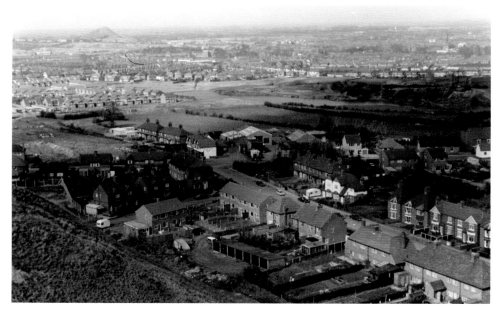

The Hare & Hounds still exists today and is visible as the white building in the centre, adjoining some industrial buildings to its right. The Glendale housing estate takes shape on the land beyond and the waters of the 'Cloddies', formerly Stanley Brothers, clayholes can be seen in the middle distance. The date of the photo is 1968. (Credit – Geoff Edmands)

Other Chilvers Coton beer houses included:

The Sportsman, The Miners, The Bull & Butcher, and The Bull & Bitch. All of these were beerhouses from 1830, but their former location is not known.

HEATH END ROAD

The Hare & Hounds

Bowed Lane is a small lane off Heath End Road, and it is here, in 1830, that a beerhouse was established called the The Hare and Hounds. Its main trade was from the numerous brick yards and collieries near to Heath End Road. The Hare & Hounds was turned into a proper public house that was licensed to sell the full range of wines and spirits. John Baker was listed in the trade directories of 1841 and 1850, where he was also listed as a farmer and grocer. Mary Baker held the license by 1863, T. Parker was the tenant in 1896, M. Beston in 1912, and in 1933 the licensee was A. Childs.

GRIFF HOLLOWS

The Newdigate Arms

This was a very old pub that dated back to the eighteenth century. It was known locally as 'the bloody hand', due to its pub sign depicting the form of a red bird's claw, which alluded to the Newdigate family arms. The pub ceased to dispense ale in the nineteenth century and was later used as a private house. Up until its demolition in the 1980s, the original pub sign was still stored in the cellar.

BULL RING

35. The Boot Inn

The Boot Inn was a canal side pub. Henry Randle was the landlord in 1828, in 1896 Thomas White was the licensee, and George Storer kept it in 1912. It was rebuilt as a modern pub around 1930 when the canal bridge was widened. After this, P. A. Cook was the tenant in 1933. The Boot Inn did not ultimately survive as a pub, but in September 2015 it had been converted into pleasant housing.

GRIFF

36. Griff House

A young lady, who grew up to be one of the most famous novelists in the land, was born here at Griff House. George Eliot (1819–1880) was born as Mary Ann Evans nearby at South Farm on the Arbury estate. A few months later she moved with her family to this commodious house, where she lived for the first twenty-two years of her life. While she lived here, through her childhood and early years, she observed

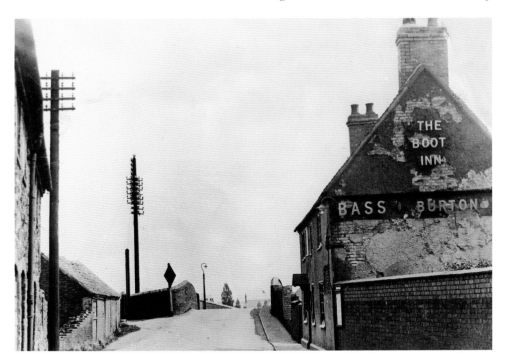

The old Boot Inn was old fashioned premises and you can see the necessity for widening the Coventry Canal bridge. A row of stone cottages can be seen on the left. A new pub was erected at the back of the old pub so that the business could still trade during alterations to the bridge. Chilvers Coton boat yard was off to the left. Note the telegraph poles which followed the line of the canal.

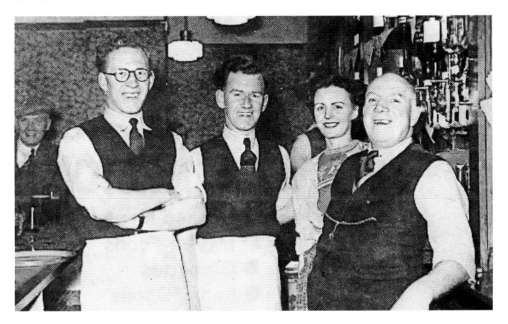

The Boot Inn bar starff, Harry Fitton, Les Fitton, May Fitton and Albert Bailey.

The Boot Inn ultimately did not survive as a pub, but by September 2015 it had been converted into pleasant housing.

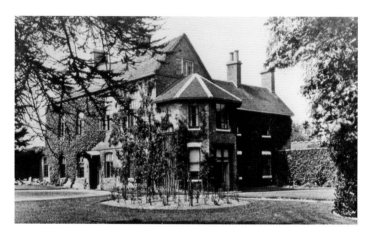

Griff House. Home of George Eliot

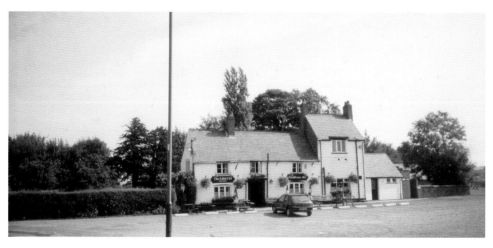

The Griffin dates back to 1654 when it was opened as a victualling house for the coal pits in the Griff coalfield. It has a reputation for being haunted.

some of the scenes that she would later paint into her stories that later became so well-known worldwide. She was schooled at Griff, Attleborough and Nuneaton, and travelled around with her father (Robert Evans), who was the estate manager for the Newdegate family. He also managed estate affairs for other local landowners.

37. The Griffin

The Griffin was opened in 1654 and served the hamlet of Griff and its surrounding collieries. The first landlord was William Friswell, a butcher by trade. The license was granted for the use of carters and miners, generally at the nearby pits in Griff. This location was far more important back in 1654; in 1662 it had forty houses. William Friswell was succeeded by Thomas Hankinson as landlord; there are no records between 1704 and 1786 when William Waddams kept it. By 1801 William had been superseded by Hannah Waddams, she remained there until 1819 when the license was taken by William Lawrence who is recorded as still having been there in 1828. Later landlords were Thomas Finney (1842), Emily Finney (1866), Charles Morris (1874), and Joseph Randle (1892–1900). In 1912, the pub was tenanted by W. Riley until at least 1916. The landlord in 1933 was W. H. Heatley, followed by Harold Day. The pub was sold to Eadies Brewery *c.* 1902.

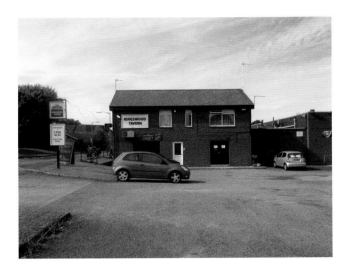

The Kingswood Tavern, September 2015.

Stockingford

CHURCH ROAD

The Lamb and Flag, No. 287 Church Road
This was a beerhouse from 1830. A new building was erected around 1898 or 1899 designed by Arthur Moreton (1864–1931), an eminent local architect who was also responsible for the Queens Head in Church Street, Nuneaton. By 1912 Thomas White was the tenant and in 1933 the landlord was E. G. Harrison.

The Engine
An 1830 beerhouse. The name The Engine might have been associated with a Newcomen or Boulton & Watt engine as the railway did not reach Stockingford until 1864, by which time the Engine beerhouse had probably fizzled out.

KINGSWOOD ROAD

The Galley Gap (renamed the Poacher's Pocket)
A modern estate pub located on Kingswood Road. Its name was derived from its location at the edge of Galley Common. It opened in 1984 at a cost of £500,000, and the first landlords were Brenda and George Davies. After a chequered career, it closed then reopened as the Poachers Pocket. In its final years it was plagued by vandalism and theft. The last landlord, David Sullivan, had to close the pub after only thirty-eight days because of this problem on 31 July 2007. It was burnt out by vandals shortly after it closed.

The Kingswood Tavern
I guess there was not sufficient trade for two pubs in Kingswood Road. The Kingswood, unlike the Galley Gap, has survived and currently has a large events room for live music, discotheques and public functions. It seems to be thriving, likely due to being surrounded by a large estate.

BUCKS HILL OR SNOW HILL

The Bucksford
A modern estate pub on Bucks Hill. It opened on the 21 May 1981, but had a short existence and was burned out by an arson attack two weeks after it closed in January 2008.

The Cripples Inn
A public house that pre-dated the 1830 beerhouse boom. It was later replaced by the New Inn, on the same site, and rebuilt. The New Inn was pulled down in the last twenty years so that a block of apartments could be built. H. E. Sephton was the landlord in 1933 to approximately 1939.

CROFT ROAD (FORMERLY SWAN LANE)

The Black Swan, No. 301 Croft Road

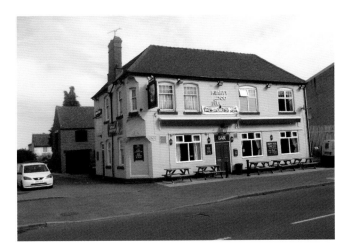

Right: Hearty Goodfellows, September 2015.

Below: The Royal Oak, September 2015. Another fine pub in excellent condition externally.

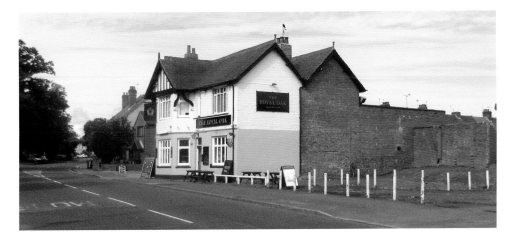

This beerhouse was established in 1830. Walter Handley (1783–1860) was a farmer who expanded to include a brick yard and coal mine. He also opened the Black Swan on Arbury Lane to slake the thirst of his employees and others from round about. The road (now Croft Road, but at the time was Swan Lane) lead up to the pub from Nuneaton town. Since the name of the road preceded the pub, one wonders if the name 'Black Swan' somehow obtained its title from the roadway it occupied. In 1912 the licensee was R. Jukes and George F. Pegg was the landlord from 1933 to around 1939.

The Hearty Goodfellows, No. 285 Arbury Road

This previous 1830 beerhouse is still extant today. Nowadays, it is a Marstons house. John Baxter was the landlord in 1912. J. H. Boulstridge took it over in around 1933 and was there until at least 1938 or 1939. In addition to the usual pub fare, John offered teas as well. It still has a quick service and popular prices.

The 'Old' Cherry Tree, No. 290 Croft Road

The Cherry Tree pub started life in Croft Road, opposite to Stanley's brickyard. At one time the pub brewed its own ale and competed with Nuneaton Brewery for its sales off the premises.

It was originally a beerhouse, established in 1830. In 1912 it was tenanted by H. Bell. The Cherry Tree moved site in the late 1930s to Haunchwood Road. A. Rowlands was the landlord from 1933 to around 1938.

ARBURY ROAD

The Prince of Wales, No. 49 Arbury Road

The tenant in 1912 was Mrs Pegg. The landlord in 1933 was John Ellis.

The Royal Oak, No. 337 Arbury Road

The landlord in 1912 was Mrs Haddon and in the 1930s it was H. Sephton.

NORTHUMBERLAND AVENUE

The Sunnyside

The Sunnyside is a modern estate pub, which had no predecessors. It takes its name from a block of terraced houses that were built by Stanley Brothers Ltd in Croft Road. Northumberland Avenue is on the site of their former brickyard.

WHITTLEFORD ROAD

Midland Railway

Up until 1923 the Midland Railway passed through Stockingford. The pub was named after the railway company, whose Leicester–Birmingham line was close by. R. Foster was the tenant in 1912 and T. Brown was the landlord in 1933.

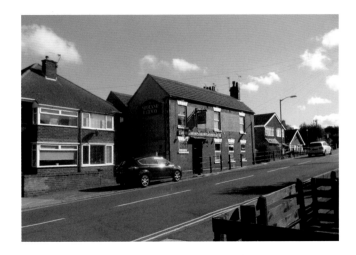

The Midland Railway.

The Miners Arms.

The White Lion.

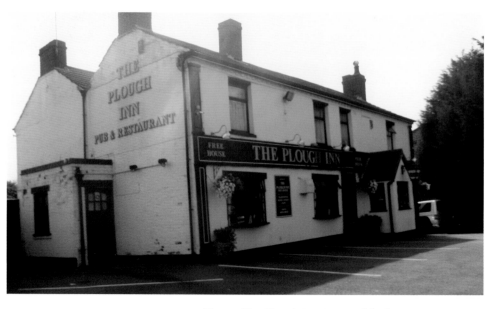

Above: The Plough Inn is one of the longest surviving pubs in the Nuneaton area. It can certainly be dated back to 1753, possibly in this same building (photographed in September 2015).

Left: The Plough Inn for sale in 1900.

With Possession.

STOCKINGFORD,
Near Nuneaton, Warwickshire.

Valuable Freehold Fully-Licensed Public-House.

TO be Sold by Auction, by Mr. J. WALKER BRIGGS, at the

NEWDEGATE ARMS HOTEL, NUNEATON,

On Wednesday, the 25th day of April, 1900,

At ½ for 6 o'clock p.m., subject to Conditions incorporating the Common Form Conditions of the Birmingham Law Society.

All that very Valuable Freehold Old-established and well-frequented Fully-Licensed

PUBLIC-HOUSE,
KNOWN AS
"THE PLOUGH INN,"

Situate at Stockingford, near Nuneaton, in the county of Warwick, and as now and for the past 20 years in the occupation of the owner, Mr. Daniel Neale, the same having been in the family for the last 35 years and upwards.

The House contains Tap Room, Bar, Smoke Room, Large Club Room, 20ft. by 15ft.; Large Kitchen, with good Range, Pantry, and Three good Cellars; also Three Large Bedrooms.

The Outbuildings consist of Stabling for 5 Horses, 2 Pigstyes, 2 Closets and other Outbuildings, and good Draw-in Yard.

There is an excellent Well, with a never-failing supply of Water.

ALSO ALL THOSE

TWO FREEHOLD COTTAGES

Adjoining the said Inn, on either side thereof, with large Gardens and usual Outbuildings, in the respective occupations of Joseph Besson and Job Percival, at weekly rents amounting to £16 18s. per annum.

Together also with the GARDEN and ORCHARD at the back of the Inn, the whole comprising an area of 0a. 3r. 21½p. or thereabouts, and having a frontage to the main road of 106ft.

The Inn is situated on the main road between Chapel End and the Tunnel Colliery, in the centre of a large Mining population, and is doing a large and lucrative business.

The purchaser will be required to take to the License, Fittings, Fixtures, and Stock-in-Trade at a Valuation.

The purchaser will also have the option of taking on Lease from Michaelmas next, at a reasonable rent, and subject to the usual Conditions, a CROFT OF LAND adjoining the Orchard at the back of the Inn, suitable for a Football and Cricket Field, containing an area of 2a. 1r. 19p., for 7 or 14 years, at the option of the purchaser.

To View, apply on the premises; and for further particulars and Plan, apply to the Auctioner, Atherstone; or to ALFRED SALE,
 Solicitor, Atherstone.

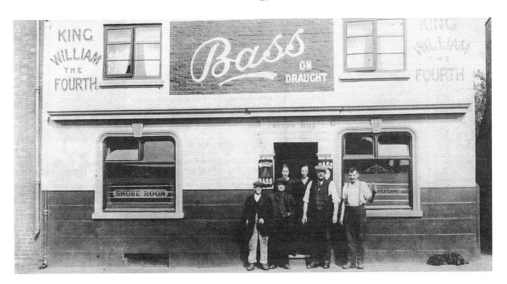

A selection of Mr Hall's customers at the King William the Fourth (Credit – Nuneaton News).

The Miners Arms
This pub has fared well and has been tastefully modified. It serves a large catchment area of local housing estates.

The White Lion, No. 345 Croft Road
Recorded landlords include Mary Jeffcote (1806), Thomas Johnson (1828), John F. Grundy (1912), and B. Styles (1933). The White Lion is a fine pub, still surviving today,. It adds a lot to the streetscape of Stockingford.

CHAPEL END, PLOUGH HILL ROAD

The Plough Inn
The Plough was called the Hollybush until 1753 and it has had a long and interesting history. It is conveniently placed close to vital miners at a local pit, more or less in its back yard, as well as the miners and brickyard hands locally. Absalom Bindley was the owner until he sold it in 1859. It later fell into the hands of David Neale and his family, where it remained for thirty-five years until it was sold again in 1900. James Davis was the landlord in 1912, W. Cart was the landlord in 1933 and W. Hewitt in around 1939.

COLESHILL ROAD

King William IV
The King William IV was often referred to by local people as 'tranters', after the name of a former landlord, Ted Tranter, who kept it for twenty years. Ted had been a miner at Baddesley Colliery and, in the time-honoured manner of old miners, went into the pub trade. He moved into the pub in 1965, where he took over from Danny Hall. Before

The Chase.

The Salutation Inn.

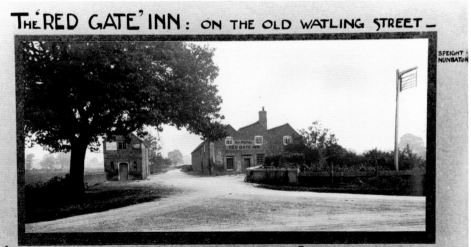

The Red Gate *c.* 1900.

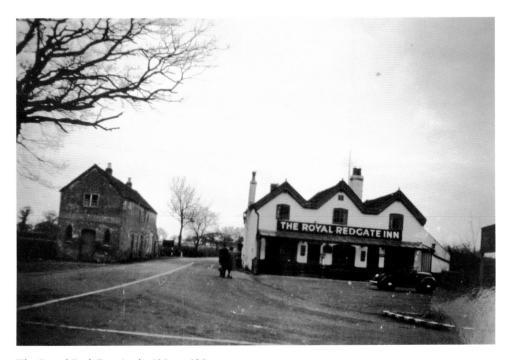

The Royal Red Gate in the '20s or '30s.

Another view of the Red Gate from the '20s or '30s.

this, the pub seems to have been in the Hall family for upwards of fifty years. When Ted took over, the whole pub needed redecorating and one of the rooms had a very decidedly greasy look to it. After it had been decorated, Ted was baffled to find that the grease reappeared, until one of his customers told him that many years ago the room was used to store and hang sides of bacon. Another unusual feature was that the cellar had a stream running through it that would flood and fill the cellar up. A large source of the pub's trade were miners from Ansley Hall Colliery, the NCB workshops, and a bus stop that was conveniently positioned outside the door. The Tranters retired in 1983, but despite continuing under new management, the pub was demolished in 1990.

The Chase

The Chase on Coleshill Road stood almost opposite the King William IV pub. It must have had a decent trade in years past, but one wonders in this modern age whether it will have a future as a pub; while it was closed in September 2015, it looks in reasonable repair, but this busy corner location might be a problem.

CHANCERY LANE

The Salutation Inn

Randle was the landlord in 1912. Percy Mellor was the landlord in 1933. It is a charming pub with large bay windows. Long may it survive!

THE WATLING STREET

The 'Royal' Red Gate Inn

Old pub names can sometimes yield very important clues about the history of the building and its environs, but often the original meaning remains lost to modern generations. This is almost the case for the Royal Red Gate Inn, which lies on the Leicestershire/Warwickshire border on Watling Street, where it crosses the A444. The reason I have said 'almost' is because we seem to know who the royal personage was that gave the famous pub its name. Queen Adelaide is accepted by generations of local historians as the famous person in question. However, we do not know what her connection was with the old pub, or what she was doing in this part of the Midlands at that time. Rumour has it that she was in transit from Warwick Castle to Gopsall Hall to stay with the Curzon family, she needed to use the toilet and so stopped at the Red Gate for a pee!

Queen Adelaide was the German born consort of King William IV (1765–1837) and was born on 13 August 1792. By the time of his marriage to this noble lady (who was half his age), William had already fathered ten illegitimate children by his liaison with an Irish actress named Dorothea Bland, but better known by her stage name – Mrs Jordan. Adelaide was the daughter of George I (Duke of Saxe-Meiningen) and Louise of Hohenlohe-Langenburg. Her title was H. S. H. Adelaide Louise Therese Caroline Amalie, Princess of Saxe-Meiningen. She married the future king on 11 July 1818 at Kew Palace in Richmond, Surrey. Their marriage was extremely sad as out of their seven children, five were born stillborn. Only two survived long enough to be named, but of those only one lived, although it was just for a few months.

When William's older brother, King George IV, died in 1830 without any surviving issue the Crown passed to him (as the oldest brother) and on 26 June 1830, he was crowned king.

In many aspects William and his wife Queen Adelaide brought a different dimension to the monarchy, compared to his extravagant brother. Queen Adelaide received a great deal of sympathy from people because they knew of her numerous children who had not survived infancy, and she also seems to have travelled about the country extensively.

During the entire decade of the 1830s Adelaide made trips into Warwickshire. We know, for example, that during the period 1832–33, she travelled on at least one occasion on the road between Coventry and Nuneaton. George Eliot's father, a prominent townsman in Nuneaton at the time, recorded at least one of her journeys in those years when he accompanied her coach on its journey from Warwick Castle to Gopsall. His journey on horseback was a hard gallop in order to keep up with the speeding royal carriage.

Former landlords at the Red Gate before 1846: Thomas Freeman, maltster and farmer (after 1861); George Crane, brewer and victualler (1863); Joseph Alcock, victualler (*c.* 1870); John Bailey, victualler (*c.* 1875/76); Thomas Smith, victualler (*c.* 1880); Arthur Weston, cottager and victualler (*c.* 1896); Thomas Andrew Wright (*c.* 1900); Mrs Julia Wright (around 1904 to 1912); John James Jackson (*c.* 1916–22); and Harry Allbut (*c.* 1925–32).

Bibliography

A History of Brewing in Warwickshire, Fred Luckett, Ken Flint and Peter Lee (eds.).

Clarke, George Leonard, 'The Old Rebel', in *A Life in Nuneaton 1885–1960.*

Pigots, Lascelles, Whites, Post Office, Kellys Directorys (1828–1912).

'Public Houses of Old', in *The Tribune* (21 October 1899). A list of abandoned licenses in Nuneaton

Scrivener, Alfred, 'The Nuneaton Brewery', in *Nuneaton Observer* (1878).

The Universal British Directory, Warwickshire County Directory (1792), Courtesy the Shakespeare Record Office.

Acknowledgements

I would like to thank the following people who have all contributed to this book, through information provided, archive material supplied, photographs and many other pieces of evidence and details discovered kindly shared, support given, not to mention the assistance of my daughter Heather Lee and Anne Gore of the Nuneaton Local History Group who have carried out transcription work and typing for me: Ted Veasey, Fred Phillips, Colin Yorke, John Burton, Mark Hood, Alan Cook, Maurice Billington, Arthur Tooby, Phillip Vernon, Keith Draper, Geoff & Madge Edmands, Mort Birch, Gerry Wisher, Tony Parrott, John Jevons, Dennis Labrum, Ruby Atkins, Reg. Bull, Horace Bull, Ray Smith, Mark Hood, John Nunn, *The Nuneaton News, The Heartland Evening News, The Coventry Telegraph,* the staff of Nuneaton Library and Warwickshire Records Office.